DENNIS KELLY

THE GODS WEEP

ABOUT THE ROYAL SHAKESPEARE COMPANY

The Royal Shakespeare Company at Stratford-upon-Avon was formed in 1960 and gained its Royal Charter in 1961, as a home for Shakespeare's work, classics and new plays. The first Artistic Director Peter Hall created an ensemble theatre company of mostly young actors and writers. The core of the work was Shakespeare, combined with a search for writers who were as true to their time as Shakespeare was to his. The Company was led by Hall, Peter Brook and Michel Saint-Denis. Hall's founding principles were threefold. He wanted the Company to embrace the freedom and power of Shakespeare's work, to train and develop young actors and directors and to experiment in new ways of making theatre.

The Company has had a distinct personality from the beginning. The search for new forms of writing and directing was led by Peter Brook. He pushed writers to experiment. "Just as Picasso set out to capture a larger slice of the truth by painting a face with several eyes and noses, Shakespeare, knowing that man is living his everyday life and at the same time is living intensely in the invisible world of his thoughts and feelings, developed a method through which we can see at one and the same time the look on a man's face and the vibrations of his brain."

A rich and varied range of writers flowed into the company and have continued to do so with the RSC's renewed commitment to placing living dramatists at the heart of the Company. These include: Edward Albee, Howard Barker, Edward Bond, Howard Brenton, Marina Carr, Caryl Churchill, Martin Crimp, David Edgar, Peter Flannery, David Greig, Tony Harrison, Dennis Kelly, Martin McDonagh, Rona Munro, Anthony Neilson, Harold Pinter, Stephen Poliakoff, Adriano Shaplin, Wole Soyinka, Tom Stoppard, debbie tucker green, Timberlake Wertenbaker and Roy Williams.

Alongside the Royal Shakespeare Theatre, The Other Place was established in 1975. The 400-seat Swan Theatre was added in 1986. The RSC's spaces have seen some of the most epic, challenging and era-defining theatre – Peter Brook's Beckettian *King Lear* with Paul Scofield in the title role, Charles Marowitz's *Theatre of Cruelty* season which premiered Peter Weiss' *Marat/Sade*, Trevor Nunn's studio *Macbeth*, Michael Boyd's restoration of ensemble with *The Histories Cycle* and David Greig's and Roy Williams' searing war plays *The American Pilot* and *Days of Significance*.

The Company today is led by Michael Boyd, who is taking its founding ideals forward. His belief in ensemble theatre-making, internationalism, new work and active approaches to Shakespeare in the classroom has inspired the Company to landmark projects such as *The Complete Works Festival, Stand up for Shakespeare* and *The Histories Cycle*. He is overseeing the transformation of our theatres which will welcome the world's theatre artists onto our stages to celebrate the power and freedom of Shakespeare's work and the wealth of inspiration it offers to living playwrights.

The RSC Literary Department is generously supported by THE DRUE HEINZ TRUST.

The RSC is grateful for the significant support of its principal funder, Arts Council England, without which our work would not be possible. Around 50 per cent of the RSC's income is self-generated from Box Office sales, sponsorship, donations, enterprise and partnerships with other organisations.

Supported by
ARTS COUNCIL ENGLAND

This production of *The Gods Weep* was first performed by the Royal Shakespeare Company at Hampstead Theatre, London, on 12 March 2010. The cast was as follows:

BETH	Nikki Amuka-Bird
ASTROLOGER	Karen Archer
IAN/MAN	Neal Barry
GAVIN	Babou Ceesay
THE SOLDIER/HUSBAND	Sam Hazeldine
BARBARA	Joanna Horton
COLM	Jeremy Irons
JIMMY	Luke Norris
NADINE/WOMAN	Sally Orrock
CATHERINE	Helen Schlesinger
RICHARD	Jonathan Slinger
MARTIN/WAITER	Laurence Spellman
CASTILE	John Stahl
SECURITY GUARD/BIG SOLDIER	Matthew Wilson

All other parts played by members of the company.

Directed by	Maria Aberg
Designed by	Naomi Dawson
Lighting designed by	David Holmes
Sound designed by	Carolyn Downing
Video and Projection designed by	Ian William Galloway and Finn Ross for Mesmer
Movement by	Ayse Tashkiran
Company Dramaturg	Jeanie O'Hare
Fights by	Malcolm Ranson
Company text and voice work by	Charlotte Hughes D'Aeth and Stephen Kemble
Additional company movement by	Struan Leslie
Assistant Director	Lu Kemp
Casting by	Hannah Miller CDG
Production Manager	Rebecca Watts
Costume Supervisor	Chris Cahill
Company Manager	KT Vine
Stage Manager	Heidi Lennard
Deputy Stage Manager	Caroline Meer
Assistant Stage Manager	Nicola Morris

This text may differ slightly from the play as performed.

Production Acknowledgments
Scenery, set painting, properties, costumes, armoury, wigs and make-up by RSC Workshops, Stratford-upon-Avon. Wardrobe for Jeremy Irons by Giorgio Armani, Jeremy Irons' shoes by Cheaneys. Distressing and Breaking Down by Schultz & Wiremu Fabric Effects. Production photographer Keith Pattison. Audio description by Mary Plackett and Veronica Ward. Captioned by Janet Jackson.

Biographies

MARIA ABERG
DIRECTOR

RSC: *Days of Significance* (Director); *The Winter's Tale, Pericles* (Associate Director); *The Crucible* (Assistant Director).
this season: *The Gods Weep.*
trained: Mountview Theatre Academy and at the University of Lund, Sweden.
theatre as director includes: *Krieg der Bilder, Die Kaperer* (Staatstheater Mainz, Germany); *State of Emergency* (Gate); *Crime and Punishment* (National Theatre); *Gustav III* (National Theatre, Sweden); *Alaska* (Royal Court); *Shrieks of Laughter* (Soho); *Stallerhof* (Southwark Playhouse); *A Handful of Dust* (Institute of Choreography and Dance, Cork).
theatre as assistant director includes: *Aristocrats* (National Theatre); *Lucky Dog, The Sweetest Swing in Baseball, The Sugar Syndrome* (Royal Court); *Shakespeare Love Songs* (Globe/Neuss, Germany); *Romeo and Juliet* (Malmo Dramatiska Teater).
Maria was a senior reader at the Royal Court Theatre for two years and completed the National Theatre Studio's Directors Course in 2005.
She was nominated for the Arts Foundation Directing Award in 2009.

NIKKI AMUKA-BIRD
BETH

RSC: *A Midsummer Night's Dream, The Tempest, The Servant of Two Masters.*
this season: *The Gods Weep.*
trained: LAMDA.
theatre includes: *Doubt* (Tricycle); *Twelfth Night* (Bristol Old Vic); *World Music* (Crucible/Donmar); *Top Girls, 50 Revolutions* (Oxford Stage Co.).
television includes: *Survivors, Small Island, Silent Witness, The No. 1 Ladies Detective Agency, Torchwood, The Last Enemy, Whistleblower, Five Days, Born Equal, Robin Hood, Spooks, Shoot the Messenger, The Line of Beauty, Afterlife, The Canterbury Tales: the Man of Law's Tale.*
film includes: *The Disappeared, The Omen, Cargo, Almost Heaven.*
radio includes: *England, The Colour Purple, Master Pip, Free Juice for All, The No. 1 Ladies Detective Agency, Top Girls, Lady Play, Troilus and Cressida.*

KAREN ARCHER
ASTROLOGER

RSC: *Nicholas Nickleby* (UK/US tour).
this season: *The Gods Weep.*
theatre includes: *Generous* (Finborough); *Hamlet, Twelfth Night* (Southwark Playhouse); *Noises Off* (Centerstage Theatre, Seattle); *Misery* (Harrogate); *Phallacy, My Matisse* (Edinburgh Festival); *Mourning Becomes Electra* (National Theatre); *Memory Of Water, Life After George* (Vienna's English Theatre); *More Lies about Jerzy* (New End, Hampstead); *The Importance of Being Earnest* (Ipswich); *What the Butler Saw* (Colchester); *Ghosts* (Best Actress Nominee Manchester Evening News, Manchester Library Theatre).
television includes: *Hustle, Panorama, Holby City, Elizabeth, EastEnders, The Chief* (4 series), *Brookside, Casualty, The Strawberry Tree, Plays for Today.*
film includes: *The Mouse and the Woman, Giro City, Forever Young.*
radio includes: Numerous productions for BBC Radio. Twice a member of the BBC Radio Drama Company.

NEAL BARRY
IAN/MAN
RSC DEBUT SEASON: *The Gods Weep.*
trained: Guildhall School of Music and Drama.
theatre includes: *The Lie of the Land* (Pleasance); *The Unconquered* (tour/Brits Off Broadway Festival, New York); *The Swing of Things* (Stephen Joseph); *Festen* (tour); *To Kill a Mockingbird, Sweetheart, A Taste of Honey* (Salisbury Playhouse); *The Kindness of Strangers* (Liverpool Everyman); *Sing Yer Heart Out for the Lads* (National Theatre); *A Christmas Carol* (Lyric).
television includes: *The Bill, The Inbetweeners, Ashes to Ashes II, Law and Order, Dream Team, Life Isn't All Ha Ha Hee Hee, POW, Holby City, Serious and Organised, Silent Witness, The Vice, Footballers' Wives, In Deep, 'Orrible, The Box, McCready & Daughter, Whistleblower.*
film includes: *The Imaginarium of Dr Parnassus, Hippie Hippie Shake, These Times, Venus, The Other Man* (short).

BABOU CEESAY
GAVIN
RSC DEBUT SEASON: *The Gods Weep.*
theatre includes: *Doctor Faustus* (Stratford Circus); *A Midsummer Night's Dream, The Merchant of Venice* (Propeller/world tour); *The Overwhelming* (Out of Joint/National Theatre); *Macbeth* (Arcola/Wilton Music Hall/international tour).
television includes: *Law and Order, Whistleblowers, Silent Witness.*
film: *Severence.*

NAOMI DAWSON
DESIGNER
RSC DEBUT SEASON: *The Gods Weep.*
trained: Wimbledon School of Art and Kunstacademie, Maastricht.
theatre includes: *Krieg der Bilder* (Staatsheater, Mainz); *Rutherford &*

Son (Northern Stage); *Three More Sleepless Nights* (National Theatre); *The Container* (Young Vic); *Amgen: Broken* (Sherman Cymru); *King Pelican, Speed Death of the Radiant Child* (Drum); *If That's All There Is* (Lyric); *State of Emergency, Mariana Pineda* (Gate); *Can any Mother Help Me?* (Foursight/UK tour); *Glass House* (Royal Opera House); *...Sisters* (Gate/Headlong); *Stallerhof, Richard III, The Cherry Orchard, Summer Begins* (Southwark Playhouse); *Phaedra's Love* (Barbican Pit/Bristol Old Vic); *Different Perspectives* (Contact Theatre); *The Pope's Wedding, Forest of Thorns, Jus' a little Simply Heavenly* (Young Vic Studio); *Market Tales* (Unicorn); *Attempts on Her Life, Widows, Touched* (BAC); *In Blood, Venezuela, Mud, Trash, Headstone* (Arcola); *A Thought in Three Parts* (Burton Taylor).
film includes: *Love After a Fashion* (costume design), *Fragile* (set design).

CAROLYN DOWNING
SOUND DESIGNER
RSC: *The Winter's Tale, Pericles, Days of Significance.*
this season: *The Gods Weep.*
sound design credits include: *Krieg Der Bilder* (Staatstheater Mainz, Germany); *After Dido* (English National Opera at Young Vic); *Dimetos, Absurdia* (Donmar); *All My Sons* (Schoenfeld Theatre, New York); *Tre Kroner-Gustav III* (Royal Dramatic Theatre, Sweden); *Angels in America* (Headlong); *Andersen's English, Flight Path* (Out of Joint); *The Kreutzer Sonata, Vanya, State of Emergency, The Internationalist* (Gate); *Oxford Street, Alaska* (Royal Court); *Ghosts, Dirty Butterfly* (Young Vic); *After Miss Julie, Othello* (Salisbury Playhouse); *A Whistle In The Dark, Moonshed* (Royal Exchange); *If That's All There Is, Hysteria* (Inspector Sands); *Arsenic and Old Lace* (Derby Playhouse); *The Water Engine* (Theatre 503/Young Vic); *Blood Wedding* (Almeida); *Gone To Earth*

(Shared Experience); *No Way Out* (*Huis Clos*), *Stallerhof* (Southwark Playhouse); *The Watery Part of the World* (Sound and Fury).

associate sound design credits include: *Some Trace of Her* (National Theatre); *The Overwhelming, O Go My Man, Macbeth* (Out of Joint); *Forty Winks* (Royal Court); *By The Bog Of Cats* (Wyndhams).

IAN WILLIAM GALLOWAY
VIDEO AND PROJECTION DESIGNER
RSC DEBUT SEASON: *The Gods Weep.*
Ian is a video designer and director working with film and live visuals in performance.
design work includes: *The Kreuzter Sonata, Nocturnal* (Gate); *Medea/ Medea* (Headlong); *The Spanish Tragedy* (Arcola); *Proper Clever* (Liverpool Playhouse); *The Tempest* (Lightworks/Parrabolla); *Blood* (Royal Court); *Starvin* (Fitzgerald & Stapleton); *Julius Caesar* (Barbican); *A Minute Too Late, Battleship Potemkin* (Complicite); *Hitchcock Blonde* (Alley Theatre Houston/South Coast Repertory LA); *Hotel de Pekin* (Nationale Reisopera, Holland); as well as designing for live music and directing various shorts and promos.
He works as part of Mesmer, a collaboration of video and projection designers working in theatre, dance, opera, fashion and music.

SAM HAZELDINE
THE SOLDIER/HUSBAND
RSC DEBUT SEASON: *The Gods Weep.*
trained: RADA
theatre includes: *The York Realist* (Riverside Studios); *The Homecoming, Twelfth Night* (York Theatre Royal); *Snowbound* (Trafalgar Studios); *Othello* (Salisbury Playhouse); *Hamlet* (ETT tour/West End); *Blues For Mister Charlie* (Tricycle).
television includes: *Paradox, Waterloo Road, Persuasion, Life on Mars,* Midsomer Murders, Robin Hood, Shameless, New Tricks, Foyles War, The Extraordinary Equiano, Dalziel & Pascoe, Holby City, The House That God Built, Passer By, Prime Suspect VI.
film includes: *The Wolf Man, Just Before Dawn, The Hollow, Good as Gone, Trip, Chromophobia, Bridget Jones: The Edge of Reason, A Fantastic Space, Offending Angels.*

DAVID HOLMES
LIGHTING DESIGNER
RSC: *Days of Significance.*
this season: *The Gods Weep.*
trained: Theatre Royal, Glasgow and the Guildhall School of Music and Drama.
theatre includes: *Cat on a Hot Tin Roof* (Novello Theatre, London); *Gurrelieder* for the London Philharmonia Orchestra conducted by Esa-Pekka Salonen (Royal Festival Hall); *Ma Vie en Rose* (Young Vic); *Alaska* (Royal Court); *After Miss Julie, Othello* (Salisbury); *Widowers' Houses, A Taste of Honey, See How They Run, Pretend You Have Big Buildings, Cyrano de Bergerac, The Trestle at Pope Lick Creek* (Royal Exchange); *Rusalka* (English Touring Opera); *Victory: Choices in Reaction* (Arcola); *Gagarin Way* (Bath); *The Rise and Fall of Little Voice, Rope* (Newbury); *Blood Wedding* (South Bank); *Things of Dry Hours* (Gate); *Sweetness and Badness* (Welsh National Opera); *TILT* (Traverse, Edinburgh); *Humble Boy* (Northampton); *Fijis* (South Bank and The Place); *The Secret Rapture* (Chichester); *Twelfth Night* (Cambridge); *Look Back In Anger* (Exeter).

JOANNA HORTON
BARBARA
RSC: *Days of Significance* (tour).
this season: *The Gods Weep.*
trained: Royal Scottish Academy.
television includes: *Foyle's War, Afterlife, Eleventh Hour, Spooks, Robin Hood, Five Days, Doctors, Holby Blue, Bike Squad, The Bill, Midnight Man, Breaking the Mould, New Tricks.*
film: *Fish Tank.*
radio: *Sandmen of the Golf.*

JEREMY IRONS
COLM
RSC: *Richard II* (and Barbican), *The Rover* (and Barbican), *The Winter's Tale, Wild Oats* (RSC/Aldwych/Piccadilly Theatre).
this season: *The Gods Weep.*
theatre includes: *Impressionism* (Broadway); *Never So Good* (National Theatre); *Embers* (Duke of York's); *Camelot* (Hollywood Bowl); *A Little Night Music* (Lincoln Center/New York City Opera); *The Real Thing* (Best Actor from Drama League and Tony Award. Broadway); *Rear Column* (Clarence Derwent Award. West End); *The Taming of the Shrew* (New Shakespeare Company/Roundhouse); *The Caretaker, Much Ado about Nothing* (Young Vic); *Godspell* (Roundhouse/Wyndham's); *Diary of a Madman* (Act Inn Lunchtime Theatre).
television includes: *Georgia O'Keefe, The Colour of Magic, Elizabeth I* (Golden Globe Award), *Longitude, Tales from Hollywood, The Dream, The Captain's Doll, Brideshead Revisited, The Voysey Inheritance, Langrishe Go Down, Love for Lydia, The Pallisers.*
film includes: *Appaloosa, Eragon, Casanova, Kingdom of Heaven, The Merchant of Venice, Being Julia, Swann in Love, The Mission, Chorus of Disapproval, Kafka, Waterland, Damage, Stealing Beauty, M. Butterfly,* *Callas Forever, The Man in the Iron Mask, Lolita, Die Hard with a Vengeance, Betrayal, Moonlighting, Danny Champion of the World, Reversal of Fortune* (Academy Award), *Dead Ringers, The French Lieutenant's Woman.*
voice: *The Lion King.*

DENNIS KELLY
WRITER
RSC DEBUT SEASON: *The Gods Weep.*
theatre includes: *Debris* (Theatre503/BAC); *Osama the Hero* (Hampstead); *After the End* (Paines Plough/Traverse/The Bush/UK and international tour); *Love and Money* (Young Vic/Royal Exchange); *Taking Care of Baby* (Hampstead/Birmingham Rep); *Orphans* (Paines Plough/Traverse/Birmingham Rep/Soho). Plays for young people include: *DNA* (National Theatre) and *Our Teacher is a Troll* (National Theatre of Scotland).

His plays have been performed in over thirty countries worldwide and translated into nearly twenty different languages. He has won multiple awards including The John Whiting and The Meyer Whitworth and is currently under commission by the RSC to write the book for a new musical version of Roald Dahl's *Matilda* to be staged in late 2010.

LU KEMP
ASSISTANT DIRECTOR
RSC DEBUT SEASON: *The Gods Weep.*
trained: LEM at Lecoq, Paris and with Anne Bogart's SITI Company, New York.
theatre includes: Lu has two theatre pieces currently touring: *If That's All There Is for Inspector Sands* (Winner of the Edinburgh International Festival Fringe Prize '09) and *One Thousand Paper Cranes*, programmed at Edinburgh's International Children's Festival this May (the Bank of Scotland Imaginate Festival). She has directed at the Northampton Royal Theatre, the Tron Theatre, the Stephen Joseph Theatre and the Riverside Studios.

radio includes: Lu was a staff radio director at the BBC between 2002 – 2007. She continues to freelance in radio, her recent piece *Deja-Vu* - a bi-lingual collaboration between BBC London and Arte Radio Paris - was a finalist in the Prix Europa Radio Fiction Prize 2009.

LUKE NORRIS
JIMMY
RSC: *Days of Significance.*
this season: *The Gods Weep.*
trained: Central School of Speech and Drama.
theatre includes: *War Horse* (National Theatre/West End); *How to Disappear Completely and Never be Found* (Southwark Playhouse); *Shoot/Get Treasure/Repeat* (Paines Plough); *White Boy, Fish and Co., Hold It Up* (National Youth Theatre at Soho).
television includes: *Skins, Inbetweeners.*
film includes: *The Duchess, Running for River, Mine.*
radio: *Choice of Straws.*

SALLY ORROCK
NADINE/WOMAN
RSC DEBUT SEASON: *The Gods Weep.*
trained: Drama Studio London.
theatre includes: *Sing Yer Heart Out for the Lads* (Pilot Theatre/tour); *Get Carter* (tour/Edinburgh Festival); *the Minotaur* (Crucible); *Macbeth, A Midsummer Night's Dream, Henry V* (Nuffield); *Platform* (ICA); *Educating Rita* (tour/Tour de Force Theatre Co.); *A Midsummer Night's Dream* (Queens Theatre, Hornchurch); *Kvetch* (Battersea Arts Centre); *Hamlet* (Horla Theatre Co.).
television: *Holby City.*
film: *Couriers.*
radio includes: *Being Brave, Wordsmith, Beautiful Henry, Giselle.*

MALCOLM RANSON
FIGHT DIRECTOR
RSC: Over 50 shows including *King Lear, Macbeth, Romeo and Juliet, Days of Significance, The Plantagenets, The Venetian Twins, The Fair Maid of the West, The Lion, the Witch and the Wardrobe* and *The Twin Rivals.*
this season: *The Gods Weep.*
other theatre includes: *Sister Act* (West End), *Cyrano* (Chichester Festival Theatre), *Les Liaisons Dangereuses, Cyrano the Musical, Oklahoma!, Not About Nightingales* (Broadway); *A Streetcar Named Desire, Troilus and Cressida, Dinner, The Relapse, Private Lives, Peter Pan* (National Theatre); *The Wars of the Roses, As You Like It* (English Shakespeare Company); *Calico, The Woman in White, Bombay Dreams, Noises Off, La Cava, Cat on a Hot Tin Roof, Les Misérables, Blackbird, Les Liaisons Dangereuses* (West End). In Germany: *Three Musketeers The Musical* (Berlin/Stuttgart/Rotterdam); *Dirty Dancing* (Hamburg); *Robin Hood The Musical* (tour). US Productions include: *The Canterbury Tales, The Venetian Twins* (Guthrie Theatre); *Henry IV Part I* (Delacorte Theater, NY); *Lone Star Love* (A. E. Housman Theater, NY); *Cyrano* (Birmingham Royal Ballet) *Macbeth* (Metropolitan Opera, NY); *Carmen* (Greek National Opera).
television includes: *By the Sword Divided, Casualty, Blackadder, Submariners, Jackanory Playhouse.*
film includes: *King Lear, Twelfth Night, Feast of July, Edward II, My Kingdom for a Horse, Oklahoma!, Jesus Christ Superstar.*

FINN ROSS
VIDEO AND PROJECTION DESIGNER
RSC DEBUT SEASON: *The Gods Weep.*
Finn trained at Central School of Speech and Drama and designs video and projection for all forms of live performance.
design work includes: *Knight Crew* (Glyndebourne); *MICroscope* (Sadler's

Wells); *Mr Broucek* (Opera North); *Beggars Opera* (Vanishing Point); *Girls of Slender Means* (Stella Quines, Assembly Rooms); *Serious Money* (Birmingham Rep); *Interiors* (Vanishing Point/tour), *Shun-Kin* (Complicite/Setagaya Public Theatre, Tokyo and Barbican), *All My Sons* (Broadway); *Three Zero, A2K* (tour); *Little Otik* (Vanishing Point/National Theatre of Scotland); *Orlando* (Sadler's Wells); *Sugar Mummies* (Royal Court); *Face Of* (Dublin RDS); *An Audience with William Barlow (Deceased)* (London Architecture Biennale); *Silverland* (Arcola).

He works as part of Mesmer, a collaboration of video and projection designers working in theatre, dance, opera, fashion and music.

HELEN SCHLESINGER
CATHERINE
RSC: *The Crucible* (Best Supporting Actress, What's On Stage Awards 2007), *The Merchant of Venice, Twelfth Night.*
this season: *The Gods Weep.*
theatre includes: *The Stone, Wild East, Bear Hug, The Weather* (Royal Court); *Whipping It Up* (Bush/Ambassadors); *Comfort Me with Apples, No Experience Required* (Hampstead); *Messiah – Scenes from a Cruicifixion* (Old Vic); *Uncle Vanya* (Best Actress, Manchester Evening News Awards), *A Moon for the Misbegotten* (Best Actress, Regional Theatre Awards), *King Lear, The Illusion, The Road to Mecca* (Royal Exchange); *The Oresteia, War and Peace, Inadmissable Evidence* (National Theatre); *An Inspector Calls* (National Theatre/Garrick); *The Mill on the Floss* (Shared Experience); *Foreign Lands* (Wolsey Ipswich); *Becket* (Theatre Royal Haymarket); *The Europeans* (Wrestling School); *A Winters Tale, The Second Mrs Tanqueray* (Sailsbury); *Miss Julie* (Plymouth); *Wild Oats* (West Yorkshire); *Design for Living*

(Harrogate); *Hamlet, Romeo and Juliet* (Compass Theatre).
television includes: *Criminal Justice II, Trial and Retribution, Dirty War, Inward Street, Waking the Dead, Sensitive Skin, Sex Traffic, Rose and Maloney, Holby City, The Way We Live Now, Bad Girls, The Cormorant, Bad Girl.*
film includes: *24 Hour Party People, Persuasion.*

JONATHAN SLINGER
RICHARD
RSC: *The Histories Cycle, A Midsummer Night's Dream, The Comedy of Errors, The American Pilot.*
this season: *The Gods Weep.*
trained: RADA.
theatre includes: *Yes, Prime Minister* (forthcoming at Chichester); *Power, Duchess of Malfi, The Coast of Utopia, Richard II, The Machine Wreckers* (National Theatre); *Uncle Vanya* (Young Vic); *As You Like It, Dreaming* (Royal Exchange); *The Winter's Tale, The Maid's Tragedy* (Shakespeare's Globe); *Bones* (Newcastle Live/Hampstead).
television includes: *Paradox, The Bill, Krod Mandoon, Hunter, Hustle, A Touch of Frost, Little Dorrit, Ladies & Gentleman, The Genius of Beethoven, Rosemary & Thyme, Midsomer Murders, Foyle's War, Murder in Suburbia, Cold Feet.*
Film includes: *Harmony, A Knight's Tale, Forgive and Forget, The Last September.*

LAURENCE SPELLMAN
MARTIN/WAITER
RSC DEBUT SEASON: *The Gods Weep.*
trained: Guildhall School of Music and Drama.
theatre includes: *Cyrano de Bergerac* (Chichester); *The Changeling, Cymbeline, Troilus and Cressida* (Cheek by Jowl tour/Barbican); *Kebab* (Royal Court); *Bent* (Trafalgar Studios); *Antony and Cleopatra* (Royal Exchange);

Charley's Aunt (Northcott); *They Shoot Horses Don't They?* (National Youth Theatre/Apollo/West End).
television includes: *The Tudors IV, Small Island, Henry VIII: Mind of a Tyrant, The Bill, The Waltz King.*
film includes: *The Libertine.*

JOHN STAHL
CASTILE
RSC: *The Crucible, Tamar's Revenge, Dog in the Manger, Pedro the Great Pretender.*
this season: *The Gods Weep.*
trained: Royal Scottish Academy of Music and Drama.
theatre includes: *Troilus and Cressida, The Frontline, Othello, We the People* (Shakespeare's Globe); *Macbeth* (Royal Exchange); *Carthage Must be Destroyed* (Theatre Royal, Bath); *Ghosts* (Bristol Old Vic); *Mary Stuart* (National Theatre of Scotland); *Alice Trilogy, The Weir* (Royal Court); *Blue Eyes and Heels* (Soho); *Professor Bernardi, Bread and Butter* (Oxford Stage Co./Dumfounded).
television includes: *Rebus, Holby City, Doctors, Murder Rooms, Glasgow Kiss, Take the High Road, Dr. Finlay, Taggart, Sense of Freedom, Albert and the Lion.*
film includes: *Loch Ness, Finding Bob McArthur.*

AYSE TASHKIRAN
MOVEMENT DIRECTOR
RSC: *Days of Significance.*
this season: *The Gods Weep.*
trained: Bristol University and Lecoq, Paris.
theatre includes: *Sweeney Todd* (Welsh National Opera MAX); *Chi Chi Bunichi* (tour); *Feast on the Bridge* (Thames Festival); *Sarajevo Story* (Lyric Hammersmith); *Silent Tide, Forget Me Not* (London International Mime Festival); *Ma Vie en Rose* (Young Vic); *Macbeth* (Regent's Park); *Stacy* (Trafalgar Studios); *La Songe du 21 Juin* (national tour, France); *Brixton*

Stories (Lyric Hammersmith Studio); *The Beggar's Opera* (Blackheath Concert Hall); *Orfeo* (Greenwich) *All's Well that Ends Well* (Young Vic, Young Directors Scheme); *Here's What I Did with My Body One Day* (national tour/Pleasance).

MATTHEW WILSON
SECURITY GUARD/BIG SOLDIER
RSC: *Othello.*
this season: *The Gods Weep.*
trained: LAMDA.
theatre includes: *Psychogeography* (Southwark Playhouse); *Enemies* (Almeida); *Home* (Theatre Royal Bath); *Some Kinda Arizona* (Croydon Warehouse); *The Romans in Britian* (Crucible); *Fair* (Floodtide Productions); *There* (Royal Court).
television includes: *Blue Murder, The Bill, Ghost Squad, No Angels, Wire in the Blood, Where the Heart is VIII, Doctors.*
radio: *Life of Penguins.*

FOR THE RSC AT HAMPSTEAD

Jeremy Adams, Season Producer

Jim Arnold, Casting Assistant

Corinne Beaver, London Manager

Claire Carroll, Senior Sound Technician

Réjane Collard, Literary Assistant

David Collins, Head of Marketing

Sindy Cooper, Wigs Mistress

Julian Cree, Technical Manager

Elayne Dexter-Jones, Wardrobe Assistant

Jane Dutton, LX Programmer

Kevin Fitzmaurice, Producer

Jess Gallagher, Senior Stage Technician

Andrew Grant, Lighting Technician

Philippa Harland, Head of Press

Marion Harrison, Wardrobe Mistress

Chris Hill, Director of Sales and Marketing

Pippa Hill, Literary Manager

Sonia Hyams, Education Project Manager, London

Hannah Miller, Head of Casting

Jeanie O'Hare, Company Dramaturg

Helena Palmer, Casting Director

Lauren Rubery, London Administration Assistant

Janine Snape, Assistant Casting Director

Alex Turner, Press and Marketing Assistant

Robert Weatherhead, Senior Props Technician

Richard Williamson, Senior Lighting Technician

Marketing, Sales and Advertising, AKA Marketing (020 7836 4747)

EMBEDDED WRITERS AT THE RSC

The potential for new work at the RSC is something we take very seriously. Our embedded writer policy is just one of a raft of strategies designed to inspire playwrights.

We believe that a writer embedded with our actors helps establish a creative culture within the Company which both inspires new work and creates an ever more urgent sense of enquiry into the classics. The benefits work both ways. Actors naturally learn the language of dramaturgical intervention and sharpen their interpretation of roles. Writers benefit from re-discovering the stagecraft and theatre skills that have been lost over time. They regain the knack of writing roles for leading actors. They become hungry to put death, beauty and metaphor back on stage.

As part of this strategy we have played host to key international writers for the last three years. Tarell Alvin McCraney is our current RSC/CAPITAL Centre International Playwright in Residence. He works in the rehearsal room with the Ensemble Company on our Shakespeare productions. Whilst contributing creatively to the work of the directors and actors he is also developing his own writing and theatre practice. His new play for the RSC will be performed by this current Ensemble in 2011. His post is funded by the CAPITAL Centre at Warwick University where he teaches as part of his residency.

We also invite British writers to spend time with us in the rehearsal room and contribute dramaturgically to both our main stage Shakespeares and our Young People's Shakespeare. There is a generation of playwrights who are ready to write their career-defining work. We are creating conditions at the heart of the RSC in which this generation can take themselves seriously as dramatists and thrive.

JOIN US

Join us from £15 a year.

Join today and make a difference

The Royal Shakespeare Company is an ensemble. We perform all year round in our Stratford-upon-Avon home, as well as having regular seasons in Newcastle upon Tyne and London, and touring extensively within the UK and overseas for international residencies.

With a range of options from £15 to £10,000 per year, there are many ways to engage with the RSC.

Choose a level that suits you and enjoy a closer connection with us whilst also supporting our work on stage.

Find us online

Sign up for regular email updates at www.rsc.org.uk

Join today

Annual RSC Membership costs just £15 (or £36 for Full Membership) and provides you with regular updates on RSC news, advance information and priority booking.

Support us

A charitable donation from £100 a year can offer you the benefits of membership, whilst also allowing you the opportunity to deepen your relationship with the Company through special events, backstage tours and exclusive ticket booking services.

The options include Shakespeare's Circle (from £100), Patrons' Circle (Silver: £1,000, Gold: £5,000) and Artists' Circle (£10,000).

For more information visit www.rsc.org.uk/joinus or call the RSC Membership Office on 01789 403 440.

TRANSFORMING OUR
THEATRES

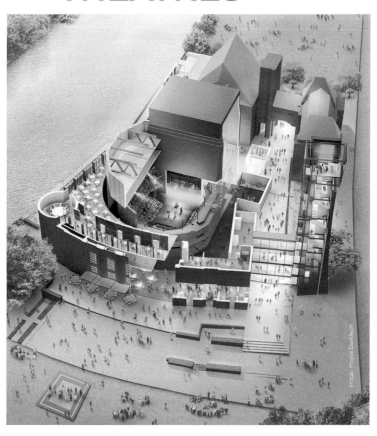

In 1932, following the 1926 fire which destroyed much of the original Shakespeare Memorial Theatre, a new proscenium arch space opened in Stratford-upon-Avon, designed by Elizabeth Scott. Now known as the Royal Shakespeare Theatre the building boasted a spacious, fan-shaped auditorium housed inside Scott's art-deco inspired designs.

And now the RST is undergoing another transformation from a proscenium stage to a one-room space allowing the epic and intimate to play side by side.

At the heart of the project will be a new auditorium. Seating around 1,000 people, the stage thrusts into the audience with theatregoers seated on three sides, bringing the actor and audience closer together for a more intimate theatre experience.

The new space will transform the existing theatre, retaining the key Art Deco elements of the building. A new Theatre Tower with viewing platform, theatre square for outdoor performances, a linking foyer to join the Royal Shakespeare and Swan Theatres together for the first time, and new public spaces are central to the new building.

7,000 people have already supported the transformation from over 40 countries worldwide. To find out more and to play your part: **www.rsc.org.uk/appeal**

The regional leader for
developing economic prosperity

LOTTERY FUNDED

ROYAL SHAKESPEARE COMPANY

HampsteadTheatre

Hampstead Theatre is one of the UK's leading new writing companies – a company that has just celebrated its fiftieth year of operation.

Throughout its long history the theatre has existed to support a thriving local, national and international playwriting culture. We commission plays in order to enrich and enliven this culture. We support, develop and produce the work of new writers, emerging writers, established writers, mid-career writers and senior writers and have a proud tradition for creating the conditions for their plays and careers to develop.

The list of playwrights who had their early work produced at Hampstead Theatre and who are now filling theatres all over the country and beyond include Mike Leigh, Michael Frayn, Brian Friel, Terry Johnson, Hanif Kureishi, Simon Block, Abi Morgan, Rona Munro, Tamsin Oglesby, Harold Pinter, Shelagh Stephenson, debbie tucker green, Crispin Whittell, Roy Williams and Dennis Kelly.

The Creative Learning programme is also an integral part of Hampstead Theatre's work. We aim to celebrate all aspects of the creative process in ways which support learning and widen access to the theatre's programme. Inspiring creativity and developing emerging talent, at its best our work has the power to change lives.

In January 2010, Edward Hall was appointed Artistic Director of Hampstead Theatre. Hall's inaugural season will commence in autumn 2010.

Hampstead Theatre, Eton Avenue, Swiss Cottage, London NW3 3EU

www.hampsteadtheatre.com

Supported by
ARTS COUNCIL
ENGLAND

Registered charity number: 218506

THE GODS WEEP

Dennis Kelly

THE GODS WEEP

OBERON BOOKS
LONDON

First published in 2010 by Oberon Books Ltd

521 Caledonian Road, London N7 9RH

Tel: 020 7607 3637 / Fax: 020 7607 3629

e-mail: info@oberonbooks.com

www.oberonbooks.com

A catalogue record for this book is available from the British Library.

ISBN: 978-1-84002-992-5

Cover image by AKA

Printed in Great Britain by CPI Antony Rowe, Chippenham.

Characters

COLM

CASTILE

JIMMY

IAN

GAVIN

NADINE

RICHARD

CATHERINE

MARTIN

THE ASTROLOGER

SECURITY GUARD

BETH

HUSBAND

BARBARA

OLD SOLDIER

Also: Waiter, Big Soldier, Officer,
Woman, Man and Soldiers

.

First Act

Board meeting. COLM, CATHERINE, RICHARD, CASTILE, NADINE,
GAVIN, MARTIN, JIMMY, and IAN, COLM at the head of the table.

COLM: …absolute panic, terror, sweating, drenched, I was
drenched in my own sweat, all over my brow, my armpits,
my chest covered, my groin, the backs of my knees and
my upper lip, and I was screaming, although I wasn't
screaming. I was screaming without screaming, my mouth
was open and screaming but my throat was incapable of
unclenching long enough for the air to sufficiently pass
through my vocal chords and produce the required sound
to scream, and so I was screaming without making a
scream.

And I knew instantly that I was no longer dreaming. The
dream was over, I knew that, the horror was gone but the
fear still gripped my heart like a fist and I thought 'I'm
going to die.' I knew I wasn't going to die, I was safe, I
knew that, but I thought 'I'm going to die.' And here's the
thing, the thing is, here's the thing, the thing was that I
welcomed that thought. But I was horrified of it at the same
time because I thought if I die, if I die, you see, who am
I? Who have I been? Who have I been and what have I
done?

Beat.

And I went down stairs. And I went into the study and I
poured a whisky into a cut crystal glass, a good whisky,
a very good whisky. And I took it into the downstairs
bathroom, and I sat on the toilet, in my pyjamas, like it
was a dining room chair, the smell of whisky engulfing me,
surrounding me.

And I stared at myself in the mirror. I stared at this face
and I thought 'who's that?' I mean it was me, I knew it was
me, I wasn't insane or panicking I knew who it was, but I
just didn't have a clue who it was.

Pause.

CASTILE: And… And what was the dream?

COLM: I dreamt that I was on a beach collecting shells.

CASTILE: Shells?

COLM: The most beautiful shells. Incredible. Beautiful. Iridescent. And there were hundreds of them, all different, all beautiful. And it gave me such joy. It gave me such a… joy, and peace, to collect these incredible shells. And it was just before dawn. And there was this thing on my belly, like, like a spot, a blackhead but large, and I squeezed it, like you would squeeze a blackhead and it squeezed out, but it was huge and it just kept coming, meters and meters of this, thick as your finger, it just kept on coming until there was a huge pile of it there on the floor. And it stank. And I looked at all my beautiful shells. And they were shit. They were just shit. They were shit shells. They were rubbish, just… shells, dirty, shit, dead things, just shit shells, just shit.

Silence.

CASTILE: Colm?

COLM: Richard. Catherine.

They step forward.

I have, in my life, done many bad things. But I have had to do bad things to make good things happen. When I took control of this company, thirty years ago, it was a third rate utilities provider. So I took it and I shaped it and I broke things to make things. I made you. All of you. I made you into beasts.

Thirty years on we now own subsidiaries across a vast range of fields; manufacturing, transport, security, petrochemical research. And it occurs to me now that perhaps we have fought enough. That perhaps growth has its limits.

Pause. They wait, not knowing if he's finished.

There has been disagreement between you two, and I have fanned those flames like a father forcing children to fight. But do we make things that can only destroy, ravenous engines of wealth that can only move in one direction? I believe it is people like us that must inherit this earth. But are we monsters?

No. No we are not. We are not monsters.

Pause.

I have two things to tell you, one small and one large. The first is that I am taking control of Belize,

JIMMY: What? But… Belize is mine.

COLM: Belize is important. I want Belize. I'm taking Belize.

JIMMY: It's, it's mine, I've been, I've been working on, it's mine –

COLM: You've failed. It is not working. I'm taking it.

Second. I am handing over complete control of Argeloin and all our interests to Richard and Catherine.

CASTILE: What?

IAN: Sorry?

CASTILE: What did you just say?

GAVIN: Is he serious?

CASTILE: What, the whole thing? Everything, you're handing over –

NADINE: Richard? Why Richard?

RICHARD glares at her.

No I don't mean… but I just mean.

RICHARD: Keep your fucking mouth closed, Nadine.

CATHERINE: How?

COLM: I'm going to divide power. Richard will be responsible for the horn of Africa, Nigeria, Morocco and what states we provide in Europe and the Middle East: Catherine, you shall take the Americas, our Asian holdings along with all Russian exploratory work and Côte d'Ivoir

CASTILE: Are you mad, Colm?

COLM: and such states as Ukraine and Lithuania should they fall into our sphere of influence. I think you'll find that this divides the net worth of the company evenly between you both. Lest there be… squabbles.

CASTILE: Are you fucking mad?

COLM: I shall retain my title as Chairman, but shall resign as CEO. My position will be nominal, somewhere from which to help and advise. Castile, who has been by my side all these years, will retain his place in the boardroom, so as to be my eyes and ears. As Chairman all of your decisions will have to be signed off by me, but this will be a formality. Purely a safeguard.

GAVIN: He's serious. He is, he's fucking serious.

COLM: This is a test.

CASTILE: A test?

COLM: For all of us. For everything. For everything in the world.

CASTILE: A fucking test?

Martin steps forward.

MARTIN: Okay, okay, lets just, please, Colm, take a step back. Please. I mean, please. Because purely from a logistical perspective this throws up all sorts of, and I'm not saying, no, this is nothing to do with, I mean Richard, Catherine; they are both very brilliant, both of you brilliant and able, but you cannot, Colm, transfer power like this in one move

and expect there not to be consequences. So, I think what we should –

COLM: Who is this?

MARTIN: Martin, I'm Martin, I'm head of –

COLM: Did I ask you?

Beat.

CASTILE: This is Martin. He's Executive Head of Communications.

COLM: Get him out of here. Clear his desk. Throw him out of the building. Tear up his contract. Let him know that if I see him again I will make sure that he remains unemployable for the rest of his life.

Beat.

HAVE I DIED? AM I DEAD? IS NO-ONE ABLE TO HEAR MY FUCKING WORDS?

Beat. CASTILE leads MARTIN out.

I have made this company. I have made decisions and my decisions have been right. This is right!

Pause.

Richard. Catherine. Together you shall forge the future.

The eyes of the world are upon us.

They all stare at him.

Yes. I think that's it.

They all leave. Except for JIMMY. Silence.

I thought your birth was a bad omen.

The pregnancy was very difficult, I couldn't help feeling relieved when you were taken out of her, I had begun to think of you as a kind of tumour.

JIMMY says nothing.

You were in an incubator for months, I couldn't touch your skin, you became this creature inside a plastic egg, this alien creature inside its plastic egg.

JIMMY says nothing.

When they put you in my arms I had to fight back the desire to swing you by your feet and dash your brains out on the wall, you were always sick and crying, you told tales on other children, you were smaller than other children, you cried in the presence of other children, you never laughed, not once, not until you were three when you saw a dog that had been run over, an animal with a broken back, dragging its hind legs, and you laughed and you laughed and you laughed. I had to fight to love you.

One of my key innovations was to fire the bottom performing eight percent of the sales team every year. That's who I have been.

I had to fight to love you. But I did love you. I do love you.

JIMMY: I can make Belize work.

COLM: No. You're failing. You're failing because you're in love.

JIMMY: How... how do you know about...?

COLM: It's my job to know. She's using your weakness. But I am so proud that I have a son with the capacity for love, Jimmy.

JIMMY: What is it I lack? What is it that they have that I lack? Tell me what they have that I don't. Tell me what I must have to be like you.

COLM: Strength. You have to have strength.

You must have the strength to take your own son's arm and break it across your knee if that is the right thing to do.

JIMMY: No. You're not, that's not, you're not that, that's not you, you're…

COLM: And then, if necessary, to take the other one and snap that too.

You don't have that.

JIMMY: When?

COLM: Two weeks. And I want you to do nothing in those two weeks, is that clear?

JIMMY: I'm so close, I can fix it. Please. I can be like you. I can.

COLM: No. No you can't. But that's good. That is good and I am so happy that you can't.

JIMMY is crying.

See? See how weak you are? But it's a wonderful thing. Cherish it.

* * *

CATHERINE and IAN.

CATHERINE: Thanks for this, Ian, I just wanted a quick word…

IAN: Oh yes, yes, of course.

CATHERINE: Because all this, it's all a bit of a shock, and…

IAN: Oh god, yes, I know. Congratulations, by the way.

CATHERINE: Oh, yes, yes, thank you, it's all such a shock and that sort of, I noticed that Richard went off with Gavin. Did you notice that? Straight away, straight away they went off together, what do you think that is?

IAN: They'll just be talking. Like us

CATHERINE: Not like us. Thick as thieves, those boys, thick as tealeaves.

Do you think Richard'll move against me?

IAN: What? No, of course not. After this? You're comrades. He'll be happy.

CATHERINE: Comrades? You think so?

IAN: Catherine, I… I think we should put problems behind us.

CATHERINE: Oh yes, yes, definitely, that's what I want to do, of course, that's exactly what I want to do. He accused me of misappropriating funds.

IAN: Catherine, listen to me. Deep down, Richard respects you.

CATHERINE: Last week he called me a cunt with a cunt

IAN: That… was inappropriate. Look, why would he move against you; he has nothing to gain by it. He's just not as smart as you.

CATHERINE: No. Neither's a rattlesnake. Poor Nadine. What an idiot, though. Did you see the way he looked at her? With his eyes, those eyes of his?

Beat.

Now, Ian; What's Belize?

IAN: Belize? It's food security.

CATHERINE: Right, right.

What's that?

IAN: Food security. It's the new thing.

CATHERINE: Is it? Great.

IAN: It's food security. We've just acquired 1.7 million hectares in Belize to secure it for farming to lease it out to wealth rich nations.

Food security is the new thing. Governments have been doing this for years – Dubai leasing land from Somalia, etc etc. China, Sweden, Libya, they're all grabbing land in Africa, South America, it's a real growth industry and it's only going to go one way. This acquisition represents the largest move in from the private sector, Colm thinks Belize is the crucible of all our hopes.

CATHERINE: Right.

Sorry, what does that mean? Is that good, a good thing, I mean don't you burn things in, aren't they for burning things?

IAN: Or forging things.

CATHERINE: Right. Right.

Actually, I think that's a forge.

IAN: Thirty billion dollars last year.

Beat.

CATHERINE: Wow. Nice.

IAN: Buy land – they're not making any more.

CATHERINE: Oh, I like that, that's very clever, you're very clever.

IAN: Actually it's Mark Twain.

CATHERINE: Yes, but you were clever enough to repeat it.

IAN: And there are rumours of something else.

CATHERINE: What else?

IAN: Some deal in the background, some huge deal. Colm's playing it close to his chest. But there are rumours.

CATHERINE: So what's the problem, with Belize?

IAN: Well; there are… rebels. And we have to send some guys over, expert soil analysts, I think, about eight guys,

you know, experts. But these rebels. Marxist or Maoist or something they see this whole thing, they're very blinkered, they don't see the benefits. So there is a fear that, these experts might get, well, killed or kidnapped. So we're having difficulty getting them… insured.

CATHERINE: What? Insured? The problem… is insurance?

IAN: Potential negligence suits for sending eight men into rebel territory are huge. We need these men insured.

CATHERINE: Fucking… insurance? Why can't we get them insured?

IAN: Jimmy.

CATHERINE: Oh. Jimmy.

IAN: Jimmy can't get the insurers to insure.

CATHERINE: Do you think it can work? Me and Richard. Together?

IAN: Catherine, I'm a team player, I don't want divisions…

CATHERINE: Oh no, me neither, I'm a team player, I'm definitely a team player, I'm the most team player of all, but the thing is I like people on my team, not the other team, not their team, in fact I don't want there to be a their team, that's how much of a team player I am.

I really like what you've been doing, and I'd like to expand that. You have a wonderful knowledge of the Americas, quotes and things, you have so much expertise. I'd like you to look after the Americas for me.

IAN: Wow. I… Thank you, I… I don't know what to say…

CATHERINE: Say yes. Would you do that for me?

IAN: Christ, yes, this is… Thank you.

CATHERINE: Well. Can't do it all on my own, now can I. It's all about being in a team. Our team. My team.

* * *

RICHARD, GAVIN and the ASTROLOGER.

RICHARD: I'm going to rip Catherine to shreds.

> *Beat.*

> I'm telling you this because you're either with me or against me. If you're with me I'll make you rich. But now you know what I'm going to do, so if you're against me I'll have to tear you to pieces too. Are you with me or against me?

GAVIN: Fucking hell, Richard, this is a bit –

RICHARD: Are you with me or against me?

> *Pause. GAVIN thinks.*

GAVIN: How rich?

> *RICHARD smiles. Turns to the ASTROLOGER.*

RICHARD: What's going to happen?

> *Pause.*

ASTROLOGER: It's not a complete picture.

RICHARD: Give me an incomplete picture.

ASTROLOGER: An incomplete picture is…

> *Long pause.*

GAVIN: Incomplete?

ASTROLOGER: incomplete, yes.

> *Beat.*

> Conflict. You're going to war.

RICHARD: With Catherine? Or with Colm?

ASTROLOGER: I can't see. Possibly one. Possibly the other. Possibly both. You will win, though. Probably. Just be

careful who you lie to. Four planets are now forming The Cardinal Cross. Saturn, Uranus, Pluto, Jupiter, it's very rare. Very exciting. Happens at big times; the great wars, great depression, fall of the Roman Empire things like that. Very exciting. Happening… now.

RICHARD waits. She has finished. He turns to speak to GAVIN.

However…

Mars is in conjunction with Saturn.

In a progressive sense.

Beat. They stare at her.

Mars is in conjunction with Saturn.

RICHARD: And?

ASTROLOGER: Mars is in conjunction with Saturn. It's very rare. It hasn't happened in over five hundred years.

Beat.

RICHARD: What does it mean?

ASTROLOGER: It means…

…be careful who you trust.

RICHARD: Can I trust you?

ASTROLOGER: We've been together for twenty years, dear, I've never lied to you yet.

RICHARD: *(To GAVIN.)* Do you believe this? You believe he's handing over power?

GAVIN: He's done it. He's off the board, I mean that's it he's

RICHARD: What about Castile?

GAVIN: What about him?

RICHARD: What do think of Castile?

GAVIN: He was a salesman. He's a tough bastard. He was in sales.

RICHARD: He's still in sales, technically.

GAVIN: Technically yes, but it's been twenty years since he's had to sell. He's Colm's right hand. He commands a lot of respect.

RICHARD: Is he dangerous?

GAVIN: Well, he's –

RICHARD: I wasn't asking you.

Beat.

ASTROLOGER: Mars is in conjunction with Saturn.

RICHARD: You keep saying that but what does it mean.

ASTROLOGER: It means Mars is in conjunction with Saturn. You asked was he dangerous. I really don't know how much clearer I can be.

* * *

A company foyer, JIMMY, drenched, a security guard in front of him. BETH shows up.

BETH: Jesus Christ, Jimmy, what are you doing here?

JIMMY: Hi Beth, how's, how's, I was just… How's it going, I was passing and

SECURITY: He can't come in.

BETH: Passing?

JIMMY: and I thought, yeah, passing sort of, and I thought I'd say hello, you know, friendly or

SECURITY: Sir, I've explained before, you can't come in, he can't come in.

BETH: You can't come in Jimmy.

JIMMY: No, no, I don't want to come in, I just want to say hello, I mean Christ.

SECURITY: We have an employees only policy after 7.30 it's 9.15 you can't.

BETH: It's nine fifteen, Jimmy.

JIMMY: I fucking know the time!

SECURITY: There's no need for language, sir.

JIMMY: I'm not giving you language, I'm not giving him language, Beth.

SECURITY: I don't get paid to be sworn at.

BETH: Don't swear at him Jimmy.

JIMMY: I'm not fucking swearing I just want to get in out the fucking rain and say fucking hello!

Pause. She nods to the security guard. Reluctantly he leaves.

JIMMY stands in front of her. Goes to say something, but doesn't. Pause. Stands there.

How's... how's your dad?

BETH: What? How's my dad?

JIMMY: Yeah, I just thought, chatting, small talk or.

BETH: My dad is terrible, what are you doing here, Jimmy?

Pause. He wipes the water from his hair.

JIMMY: Wet.

In there are you?

All in there? Making your mind up? Going over the deal?

BETH: We... we are going over, yes, we are.

JIMMY: Are you going to insure us?

Laughs. It is not funny.

Joking, joking, you can't say, of course, I'm just…

Pause.

Look no, I just thought – sorry about the joke, Beth, that was inappropriate, that was – no, I just thought, as I was passing you know, if there was any other data that you might need, I thought… Well here I am.

BETH: We don't need any other data

JIMMY: Great. So you have all the data?

BETH: Yes.

JIMMY: You have all the data you need?

BETH: Yes

JIMMY: So are you near a decision?

BETH: I can't say.

JIMMY: Jesus Christ, Beth, I'm just asking if you're near a fucking decision, you can tell me that at least.

BETH: How is that going to help?

He doesn't answer.

Right. Look. There is a process going on. We are in the process of evaluating your application and there are systems to go through. Now we have all the data, we have the statistical reports, we have more than five independent studies from which to draw upon, we have everything. I cannot pre-empt the results of that –

JIMMY: Last week I was brushing my teeth and I must've hit something in a funny way or something, maybe triggered a sort of nerve response but suddenly I could taste your vagina.

Really clearly. Really, really clearly. Isn't that odd?

Beat.

And I thought that maybe I had absorbed some of your body into mine, and I thought that for that to happen some of your molecular structure must've mingled with mine.

Beat.

And it was such a beautiful moment that I began to fantasise about being cryogenically frozen so that this moment could last forever, and I began to think that this was potentially a great business opportunity, so that you could stop time at this perfect moment and stay there, and all the pain that you've experienced since that moment had happened, the feeling that your soul had been sucked out by a vacuum cleaner and shredded into tiny pieces, the waking up in a panic and screaming, the feeling that you now had liquid shit for blood, those feelings might disappear and you might be able to stay in that perfect moment.

Beat.

What do you think? Do you, do you think that's possible?

BETH: Jimmy...

JIMMY: Could it be an investment opportunity? I wanted to ask you about that. I wanted to ask you if you consider insuring that?

Beat.

BETH: I... think that you would soon find that there was a significant gap between your technology and your projected aims.

JIMMY: I'm falling to pieces, Beth, look at what you've done to me.

BETH: I haven't done –

JIMMY: I love my wife. I love her so much. I would die if she found out. And I'm lying there looking at her and suddenly I'm thinking 'oh my god you're going to find out, you're

going to find out and I'm going to die' and I swear Beth
that my heart falls into a pit in my stomach that I didn't
even know was there, and yet at the same time I can't stop
thinking about your hair.

BETH: Okay, Jimmy, you just have to hold it together.

JIMMY: Okay.

BETH: Okay?

JIMMY: Okay. Your husband's a fucking student how is that
better than me?

BETH: Don't bring my husband into, this has nothing to do
with my… And actually, he has given up a good career
to go back to full time, which is something I respect very
much, so –

JIMMY: How's your dad?

BETH: I'm not talking about my fucking dad!

JIMMY: You see the thing is I'm not a bad looking man. I'm
not a great looking man but I'm not a bad looking man so
sometimes women want me, for, for, for say a one night
thing, like you would want a normal person, a real person.
And I think great, but no sooner have they touched my
flesh than my heart aches for them with every fibre of my
body and all pretence collapses and I just want them to
want me but they can suddenly see inside of me and see
my weakness and hunger and they are repulsed. And when
I say they, Beth, I mean you.

Are you going to reject this bid because of my weakness?

Pause. She is staring at him. Pause.

BETH: He's terrible. My dad. He's still drinking. He stinks.
Smells like someone defecated in him. But every so often
he does this smile and you think I know you and then it
disappears under the waves of snarling filth that he uses for
an expression these days.

43

He's on a list. For treatment.

They haven't got enough places. He'll die before he goes in.

JIMMY: My father's the same. Completely different, but exactly the same.

Pause. She comes closer.

BETH: Jimmy… we are not necessarily going to reject –

JIMMY: *(Recoiling.)* Oh Jesus, oh Jesus Christ you are, you're –

BETH: It's not because of what you said!

They don't want you Jimmy. Rebels or not. These are not… these regions are poor. You're buying land in poor regions, investment, you can talk all you like in your reports about vast injections of capital into growing economies but I have to deal in facts and who sees that? where's that going to go, officials? what corrupt officials? siphoning? these farmers, local farmers aren't…

Look, that aside, there are rebels everywhere. These men are a target. There's not enough provision for Security. And if you put more into Security the whole thing becomes untenable, you can't win. You're sending workers in there, they will be kidnapped. They will be killed. You will lose these men.

Pause.

JIMMY: If it was someone else you'd be saying yes. My Father would make this happen.

BETH: No, he would not make this happen.

JIMMY: He would. His would strong this. His would strong this to happen.

Pause. He moves away. She waits. Waits.

BETH: Jimmy?

JIMMY: Give me two weeks.

BETH: What for, no, we've been over everything, there's no –

JIMMY: Please, please, please fucking please, Beth, please, look at me, look at what I am, you have taken everything from me, you saw weakness on me, you saw the weakness of my love for you on me and you used that knowledge to decide about this, please.

Pause.

BETH: That is not what happened.

JIMMY: Two weeks. I'll sort everything out. I'm begging.

BETH: One week.

JIMMY: I think about you all the time.

BETH: Don't… fucking think about me ever.

* * *

RICHARD and CATHERINE, RICHARD bursting in, carrying a folder.

RICHARD: I have had enough!

CATHERINE: What? Jesus Christ, Richard, what are you

RICHARD: This, this, this… shit! This shit? Belize, this Belize… shit…

CATHERINE: Oh. I see. The report.

RICHARD: Fucking report? This, what, this?

CATHERINE: You've read the report. It's my fault, I shouldn't have sent it to you. You know it came to me, my desk, the Americas, and I thought, well, that you should see, Richard should see, but I knew it'd get you all –

RICHARD: Have you read this fucking report?

CATHERINE: You're angry, aren't you.

RICHARD: And are you happy with this? Tell me you are not happy with this

CATHERINE: I'm not happy with this

RICHARD: Are you happy with this?

CATHERINE: I am not happy with this at all

RICHARD: You are CEO, I am CEO, Colm is not the CEO. He was the CEO, now we are the CEOs, if he wanted to stay CEO he should've fucking…

CATHERINE: Twenty five percent.

RICHARD: Twenty fucking five percent. I mean fuck! It's impossible! Humanitarian provision bullshit, twenty five… have you see this?

CATHERINE: Twenty five percent of all produce to be sold locally at below market value.

RICHARD: I mean what is this Ghandi peace prize shit all of a sudden?

CATHERINE: This is just the start, I mean a thing like this? Where does it end?

RICHARD: Ghandi is it, fucking Ghandi?

CATHERINE: How does it work?

RICHARD: It doesn't fucking work!

CATHERINE: This is legacy stuff.

RICHARD: Exactly!

CATHERINE: Legacy… nonsense. The search for absolution

RICHARD: Thank you, exactly. I mean have you seen these projections?

CATHERINE: Statues in the plaza, local hospital named after you, welcome to Colm international airport and do not forget your landing cards.

RICHARD: The old Colm would never do this, I mean what book did he get this from, a book? Reading is it, night-time reading, reading at night?

CATHERINE: It's going to make success in Belize impossible.

RICHARD: *Das Kapital?* Fucking…

CATHERINE: I mean where does it all end? So: what are we going to do?

Pause. He is staring at her.

What?

RICHARD: We should take this. We should take this from him.

CATHERINE: What did you just say?

RICHARD: You heard.

CATHERINE: Yes. Yes, I did.

Beat.

RICHARD: You are CEO. I am CEO. We decide who does what. We decide who looks after what. We decide that people who design operations that will never, ever, ever be profitable do not look after said operation.

CATHERINE: Are you suggesting taking this from him?

RICHARD: I am suggesting taking this from him.

Pause.

CATHERINE: Okay.

RICHARD: Shit. I mean shit. This is big.

CATHERINE: I know, I know. Can we do it?

RICHARD: No.

CATHERINE: What?

RICHARD: The board. The others on the board. Them.

CATHERINE: Right. Them. There's a lot of loyalty on the board.

RICHARD: Loyalty? Cowardice.

CATHERINE: Colm created them, they're loyal.

RICHARD: They're cocksucking maggot fuckers.

CATHERINE: Ian, Gavin, Jimmy. Nadine…

RICHARD: Do not say Nadine's name in my presence.

Pause. He is staring at her.

CATHERINE: What?

RICHARD: What if one of us was one of them?

CATHERINE: What?

RICHARD: What if one of us was one of them.

CATHERINE: How could one of us be one of them. We're us.

RICHARD: No. Only one of us becomes us.

We hand over Belize to one of us, not both of us.

Beat.

CATHERINE: The whole thing?

RICHARD: That way the other one stays there. In the bosom of the beasts.

CATHERINE: What about Castile? He's a big presence on the board.

RICHARD: He's a big cunt on the board.

But if it looked like one of us was one of them… That one could manoeuvre. That one could ensure there was no rebellion, smooth the transition. We just hand over Belize to just one of us, fuck Castile.

CATHERINE: Everything has to be signed off by Colm. You think he'll sign this off? Us taking his own operation from him?

RICHARD: Deal with this. Then let's deal with that.

CATHERINE: Which one? Which one of us?

Beat. He shrugs.

RICHARD: I don't mind taking it.

CATHERINE: You don't?

RICHARD: No.

CATHERINE: That's good of you. So you would…

RICHARD: Yes.

CATHERINE: Be in control of…

RICHARD: Yes.

CATHERINE: be in control of Belize, then?

RICHARD: I would

CATHERINE: Right. Right.

Have you heard rumours? Of some huge deal connected with Belize?

RICHARD: No.

CATHERINE: No?

RICHARD: No, nothing? Have you heard rumours?

CATHERINE: Rumours? No, I haven't heard rumours. I haven't even heard of the rumours.

Beat.

RICHARD: So?

CATHERINE: Well, it's just that if one of us had Belize… our turnover is currently equal and this would tip the balance.

And what with all eyes on Belize if that person made a success of Belize then in the eyes of the board that person would, well, kind of be the winner between us.

RICHARD: Right.

CATHERINE: Not that there's competition, all that's behind us, of course. But if someone had Belize, that would be the balance sort of…

RICHARD: That would tip the balance.

CATHERINE: That would tip the balance, yes.

RICHARD: Right.

Of course if they fucked up that would tip the balance the other way.

I mean this insurance thing that Jimmy's been in charge of is likely to sink the whole thing.

CATHERINE: Jimmy. I mean, Jimmy. Lovely guy, but…

RICHARD: Couldn't get cunt-fucked in a brothel.

CATHERINE: Quite. So… What do we do?

Would you be willing to let me take Belize?

RICHARD: You?

CATHERINE: Yes.

RICHARD: No. Absolutely not. No offence.

CATHERINE: None taken, but you see my position?

RICHARD: I do, I do. One of us needs to take it, though. It's the only smart play.

CATHERINE: And the annoying thing is that we're essentially a team.

RICHARD: Plenty of room for both of us. Those days are over.

CATHERINE: But here we are.

RICHARD: Yes. Yes. Here we are.

Pause. Richard gets up.

Toss you for it.

He pulls out a coin, steps back.

CATHERINE: Sorry?

RICHARD: Leave it in the hands of the gods. Let fate decide.

CATHERINE: Are you serious?

RICHARD: Yes. What do you think?

Beat.

CATHERINE: Okay.

RICHARD: Heads or tails.

CATHERINE: Heads

He tosses the coin, catches it, flips it onto the back of his hand.

No, tails. Fuck it, heads.

They exchange a look and the he looks at the coin.

RICHARD: Shit.

CATHERINE: What?

RICHARD: Congratulations. You won.

He puts the coin away.

CATHERINE: You didn't show me the coin.

RICHARD: What?

CATHERINE: You didn't show me the…

RICHARD: Didn't I? Of course. Sorry. You wanna do it again?

Pause. She stares at him. He takes the coin out again. Waits.

CATHERINE: No. I'll take it.

RICHARD: Sure?

CATHERINE: Yes. Why not?

He holds out his hand to her. She shakes it.

RICHARD: It's nice to be working with you. Together.

CATHERINE: Yes. Aren't we.

He goes. She presses a button on her desk. Waits, lost in thought. After a moment JIMMY enters from another door. He goes to her, tries to kiss her, but she pulls back, still miles away.

For reasons I don't yet fully understand… I now have Belize.

He does not respond.

I think we'll go ahead with our plan.

He says nothing.

What's wrong? Don't you want Belize? Don't you want it back? You make it a success for me and I'll give it back to you. Don't you want it back?

JIMMY: Yes, I do, but… I don't know if I can do this.

CATHERINE: Of course you can. You're my brave little boy.

JIMMY: I just… I'm not sure if I can do this, I'm not sure if –

She slaps him across the face. He is shocked. Looks like he might cry. She can't help but laugh, a kind laugh, but immediately regrets it. Kisses him.

CATHERINE: I'm sorry. I'm so sorry. My beautiful boy, my beautiful, beautiful brave little soldier-boy. You can do this. Are you going to do this?

JIMMY: Yes.

CATHERINE: Are you going to do this for me?

JIMMY: Yes, I'm going to… I'm going to do this.

CATHERINE: See? See? See what you can be when you put your mind to it? So brave. My brave little soldier.

* * *

COLM, sits, coat still on. Lost in thought. CASTILE enters, taking his own coat off.

CASTILE: I've got Gavin outside. I have him outside and now we'll find out what's going on. He sitting there, terrified, like a –

Do they think they can just cut programs out of your projects? Just fucking cut, like –

I told him. I said, I said you were furious and he shat himself, Colm, he shat a house-brick. I said, I said 'I spoke to Colm on the phone last night' I said 'and let me tell you I could hear the blood rattling in his throat, Gavin' and he shat a, he's shaking, Colm, he's practically...

Beat. Notices COLM. Stares at him. Silence. For a long time.

COLM: Last night I'm sitting there having dinner with my wife. And we're not speaking. Not in a bad way. Not in a 'I've got nothing to say to you, pass the salt' sort of way but in a loving silence, a warm silence. So I'm sitting there having dinner with my wife in a warm silence. I think it was lamb. And I said 'Is this lamb?' and she said 'Yes. It's lamb. Don't you like it?' and I said 'Yes. I think I like it.' and she said 'Think? You think you like it?' and I said 'Yes. I think I like it' and she said 'Shall I tell Angelina to make you something else?' and I said 'Why would you do that when I think I like it? Isn't that a positive?' and she said 'No, that's not a positive. Not if you think you like something. It's only a positive if you like something' And I said 'well what about us? I think I like you, yet we've been married for twenty five years.' And there was a... catch,

in her being, a microsecond of shock. And I thought 'Oh Christ, I've done it now' and I didn't mean to, Castile,

I really didn't, I just thought this was a given, but she's always had remarkable powers of recovery and we just carried on, we just carried on talking.

And we carry on eating. And there are silences, yes. But comfortable silences. The silences of deep understanding. And we're chatting, and she's telling me about her brother and there's no hint of what was said, so much so that I'm beginning to think that it never really happened and then, then in the middle of a sentence, she looks up at me and says 'What do you mean "think"? What does "think" mean?'

Beat.

And I looked at her. And I saw in her face that one word from me, and she would collapse behind that smile. And I thought 'God, don't say the wrong thing' but I found myself saying 'Well, on the way home I almost asked Mario to drop me off at a brothel so I could pay a prostitute to let me fuck her in the mouth.'

CASTILE: You said…

COLM: Yes.

CASTILE: You said that to

COLM: Yes.

CASTILE: Miriam, you said that to Miriam?

COLM: Yes. Yes, I did. And she looked so… surprised. And I said, 'Look, I'm saying this because I want to be honest, don't you want to be honest? I think I love you, I think I've loved you for twenty five years, isn't that enough? Please don't tell me that that isn't enough.'

And for a second, for a fraction of a second I thought 'Here we go. Here it comes, the eruption, she's going to explode…'

And she looked at me and opened her mouth and said 'You're in a funny mood tonight.' And then she went back to the lamb.

Beat.

'You're in a funny mood tonight.'

And suddenly it occurred to me, Castile, that we had in fact been sitting in a 'pass the salt' sort of silence. That we had been sitting in that sort of silence for twenty five years. And I cried. I cried my lungs out. Inside. I cried my lungs out inside. Outside I just carried on eating the lamb.

Pause.

What do you think of me, Castile?

CASTILE: I... admire you.

COLM: Is that good? Because I'm not sure if that's good anymore.

Pause.

CASTILE: Colm, are you –

COLM: Show him in.

Beat. CASTILE opens the door.

CASTILE: Get in there, you.

GAVIN: *(Entering.)* Colm, Listen, this really has nothing to do with –

CASTILE: Shut up, you.

GAVIN: I'm just saying that this has –

CASTILE: I said to shut your fucking fuck!

GAVIN: Look there's no need for that kind of –

CASTILE: Why are you standing?

GAVIN: Because... I don't know. Do you want me to sit?

CASTILE: What do you think?

GAVIN: I think –

CASTILE: Do you? Is that what you think? That's really fucking interesting, sit your arse down before I break your legs to sit you down.

He sits.

GAVIN: Listen, Colm, I really had nothing at all to do with –

COLM: Why is he sitting?

CASTILE: Why are you sitting?

GAVIN: Because you told me to –

COLM: I didn't say for him to sit.

CASTILE: He didn't say for you to sit!

GAVIN: Look, I'm not impressed with this, all this, I'm not scared of –

CASTILE: Stand up you fucking cunt!

He stands.

You fucking cunt. You fucking cunt. Can I just kick him out, Colm, can I just fucking destroy him please, Colm, just let me fucking destroy him, Colm, you owe me that at least, please?

GAVIN: Look this is nothing to do with me!

COLM tosses a folder to GAVIN.

COLM: My humanitarian provision has been cut from this. Where is it?

GAVIN: Okay, look –

CASTILE: Shut your fucking mouth when he's speaking!

COLM: Answer my question!

CASTILE: Answer his fucking question, cunt!

GAVIN: Can I speak or are you just going to shout at me?

Beat.

Look, we did a feasibility study, this is not... This can't work. You know it can't, look at the margins, look at the... We did a feasibility study.

Pause.

COLM: Belize is mine. Belize is my project, I make decisions about what goes in and what gets cut out of my –

GAVIN: It's... it's not yours. Not any more.

Beat.

Catherine and Richard, they... they gave it to Catherine.

CASTILE: What? What did you say?

GAVIN: It's their right, you made them CEOs they are CEOs.

CASTILE: What did you say? What did you fucking –

COLM: Castile!

Beat. CASTILE steps back. COLM stands.

I want my provision back in. I want you to put my provision back in.

GAVIN: Okay. Okay, right.

No.

Beat.

They... they can do more to me than you can. They are CEOs. You made them CEOs.

COLM doesn't move. But he is shaking.

COLM: You... you little... you little... You little, you, you little you, you...

CASTILE: Colm?

COLM: you little, you little you, I will… I will, you, I will…

Beat.

Get out.

Beat. GAVIN goes. CASTILE stares at COLM.

CASTILE: What? are you going to just let him go? Don't let him go. Don't let him go like that! We can do things, we can break him, we can do so many things! They'll think you're weak! Colm.

But COLM says nothing.

Colm!

* * *

JIMMY sitting, waiting, soaked, drenched. He has not taken his jacket off.

BETH enters, wearing a nightgown.

BETH: You fucking

JIMMY: Sorry, sorry

BETH: You fucking

JIMMY: sorry, sorry, sorry –

Husband enters. Sees JIMMY. Smiles.

HUSBAND: Wow.

JIMMY: Yes.

HUSBAND: Cats and dogs.

JIMMY: Completely soaked.

BETH: This is Jimmy.

JIMMY: You must be the Husband.

The HUSBAND laughs. They shake hands.

I'm so fucking glad to meet you.

HUSBAND: You're so wet.

JIMMY: Sorry. That's what I was saying when you came in, I was saying sorry because I'm so wet.

BETH: Are you going out?

HUSBAND: I'm going out.

JIMMY: It's wet out.

They laugh.

No, it really fucking is.

HUSBAND: You swear a lot, don't you.

JIMMY: Not normally.

HUSBAND: Yeah, I'm gonna get some ice cream.

JIMMY: Do they sell ice cream now?

HUSBAND: They sell it at the garage.

JIMMY: Yeah. They do. Of course they do.

HUSBAND: Insurance bores the pants off me; you're going to talk insurance –

JIMMY: It was really fucking lovely to meet you, and sorry about the swearing.

Holds out his hand. Beat. HUSBAND smiles and shakes it. Goes.

BETH sits, almost collapsing, can't look at JIMMY.

BETH: Oh god.

JIMMY: He's nice. He doesn't seem depressed, you said he suffers from depression, but he doesn't seem at all, were you lying?

BETH: Oh my god.

JIMMY: Ice cream. See I'd never do that, that's quite American, isn't it? Popping out for ice cream, I wouldn't do that. If I popped out at night it would be for petrol or eggs or some meat, cold meat, or –

BETH: What are you doing here?

Beat.

JIMMY: Can I ask you a question? About him?

BETH: No.

JIMMY: Just one.

BETH: No.

JIMMY: Just one.

BETH: No.

JIMMY: Does he wake up in the morning and think about your breath? Does he wake up every morning with an ache in his chest because in his mind he can hear you breathe and it's causing him actual physical pain because your breath is the most beautiful thing that a human being has ever done with their actual physical bodies ever?

Does he do that?

BETH: What are you going to do?

JIMMY: I'm sorry, Beth. This is wrong. I'm having some kind of

BETH: Breakdown

JIMMY: Awakening.

I need to tell you a thing. About the country we are doing this deal in.

BETH: You don't know anything about me. You talk about, what, talk about me breathing? Is that it, talk about me fucking breathing? I just breathe, breath, that's all, he

doesn't think about it because he wakes up next to it, and then I get up, I go to the bathroom I shit and shower and sometimes I don't shower, sometimes I just wet my hair and pretend I've had a shower and I get dressed and I get a train and read a paper, or not, sometimes I don't, but I get to work and I just work, I just fucking work in this boring job, but no, not always boring because sometimes I like it but yes, I do drink too much sometimes, which was why I slept with you, no other reason just stupidity, that's all.

JIMMY: The country we are doing this deal in has applied for an international development loan. And it has somehow become linked to our deal.

Beat.

BETH: What?

JIMMY: And this loan is huge. Enormous. Very, very large. But the World Bank has said it's conditional on them opening up to private enterprise, water, transport, etc, they want them to be like us. How's your dad?

BETH: What? How's my…?

JIMMY: Yes, how's your dad, how is he?

BETH: Why are you asking?

JIMMY: Please just tell me about your dad, Beth, is that too much to –

BETH: Better. He's…

Beat.

He's better, he's much better. He's got a place in a treatment centre, it just came up last week out of the blue, he's in, gone in there already, he's much better already, he's in some place called / new –

JIMMY: New Vistas Care and Recovery Centre.

Beat. She is staring at him.

But the thing is the locals have been dragging their heels about selling off, well they see it as selling the family silver, water, transport etc, you can understand it really. And the World Bank has got a bit miffed, and it's now saying 'are you serious, are you serious about becoming like us' and somehow our little project has become, well, a sort of symbol. Of intent. Of whether the locals are serious about letting in private enterprise. And somehow, Beth, the whole loan, the whole fucking – and this is nearly trillions, Beth – hangs in the balance on whether this deal is done.

BETH: How did you know where my dad went?

Door slams. HUSBAND enters. Looks at them. Smiles.

Goes into the kitchen, returns with the ice cream and a spoon.

Sees that they are silent. Beat.

HUSBAND: Sorry, do you want some?

Beat.

BETH: No thanks.

JIMMY: What flavour?

HUSBAND: Cherry.

JIMMY: No thanks.

HUSBAND sits with his ice cream, looking at some papers and books, studying. Eats.

We are not monsters. We can make this a good thing. We do good things. Good projects. We help people who need help.

Now, their government has given us, what I like to think of as a cash back incentive. It's large, very large.

BETH glances at her HUSBAND.

BETH: That's… that's not, strictly speaking, legal.

JIMMY: No. It's very not legal. But what I am here to tell you Beth, is that this money is all going into Security. For these men. They will be safe.

She glances at her HUSBAND again, but he's lost in his papers.

Why would we want these men harmed? If they are harmed the whole thing collapses. Why would we want that, what would be in it for us?

BETH: No. I can't go on... You shouldn't have told me, you should not have –

JIMMY: I left my wife. Did I tell you that?

Beat. HUSBAND has not noticed.

I hope we can make this work, Beth.

I really need this to work, Beth.

I'm being completely honest, Beth, I really need this to work, Beth, or I don't know what I might do, Beth.

BETH: I... can't approve without evidence that proper Security is –

JIMMY: I can give you my rock solid assurance as evidence.

BETH: I need to see something, something

JIMMY: I can just say 'Beth. Please trust me. You fucking owe me that.'

She glances again at the HUSBAND.

I might have some ice cream.

BETH: Don't.

JIMMY: I might.

BETH: Don't.

JIMMY: I might.

BETH: Don't.

JIMMY: I might. I might have some.

Beat.

BETH: You're… you're giving me an assurance? They'll be okay?

JIMMY: Yes. Absolutely. I can give you a rock solid assurance that everything that has passed between us, everything will be okay.

She glances again at her HUSBAND. But again he just studies and eats ice cream.

* * *

NADINE waiting in a bar. COLM arrives. Stares at her.

COLM: Nadine?

NADINE: Yes.

COLM: Hello, I'm Colm.

NADINE: I know. I've worked for you for eight years.

Beat.

COLM: Can I sit?

He sits.

I've had a bit of a morning.

NADINE: Do you want a drink?

He thinks.

COLM: No, I don't think I do.

NADINE: Do you want to take your coat off?

He thinks.

COLM: Yes. I'll take my coat off. I'll take my coat off and put it here.

He takes his coat off and puts it on the seat.

NADINE: Are you okay?

COLM: I've just been to see someone. An old…

NADINE: friend?

COLM: friend, yes, no, not a friend, no. Someone I've never actually met.

Sorry I didn't recognise you. I think I did recognise you but if I'm honest I probably didn't put two and two together, I'm not good with names but now that I sit here I find that I know you quite well.

Pause. He is overcome.

NADINE: Colm?

COLM: *(Recovering.)* Do you think I might actually have a drink? do you think I might have a whisky sour?

NADINE: *(To a passing waiter.)* Whiskey sour. Please.

She waits for him.

COLM: Castile says you're willing to talk.

Pause.

NADINE: Belize has come through. They have the insurance, it's going to work, they are sending the men out there within days. Do you see? It was with Jimmy nothing happened, it was with you: nothing happened, it's with Catherine for a day and it's working like a dream. They are getting stronger than you. I believe they are going to move against you.

COLM: They're moving against me?

NADINE: Yes.

COLM: They're destroying me?

NADINE: Yes. Yes, they are, Colm.

His drink arrives. He drinks. She continues.

Look, this is really, I don't mind telling you, this really is very risky for me. I mean I don't know, I don't even know what the fuck I've done, but Richard, he has, he's at me in everything I do and every time he looks at me, it's, I mean I'm scared. I'm actually scared –

COLM: Have you ever destroyed someone?

NADINE: *(Beat.)* What?

COLM: Have you ever destroyed a person?

I have. Ken. He was called Ken.

And there was a rivalry. You know, friendly enough, this was when I was a younger man. Full of, you know. And he was too, we were both full of, we were the hot ones, you might say, the hot ones in town *(Little laugh.)* And one day Ken wrote something about an acquisition I was making in a trade paper, I mean ridiculous really, a circulation of a few thousand, tens of thousands, but he wrote something that was critical of me and of how I was handling the acquisition. And it was a bit off. Everyone said it was a bit off, but it wasn't exactly the *Daily Mail.*

But somehow this really got to me and I thought 'fuck you, Ken' and I decided to destroy him and I set about blocking everything he did, every time he made a purchase we would get there first, every time he moved into a market we moved in harder and no-one knew what I was doing, it was my little secret and I would do these things and then look at them and think 'I did that. Look at what I did.'

And poor Ken, he didn't have a clue, he just thought that he was losing his touch and pretty soon Ken became a jinx and then he was facing bankruptcy, but that wasn't enough for me, Nadine, because once you've tasted blood, so I hired a Private Detective who uncovered some minor infidelities which I had revealed to his wife and his family fell apart and his son became dependant on prescription

medication which I made sure he got plenty of and eventually he overdosed and died and some years later when I read that Ken had taken a gun and blown his brains out I thought 'I did that. That was me. Look at me. That was me, look at what I did.'

Pause.

He had daughter as well. Barbara. Actually that's quite a lovely name now, it wasn't then, but now... She was very young. I went there today. She's grown up now, she lives in one room, I saw it from the outside, I watched, she seems like a very nice young lady, I don't know what she does, but she seems...

I wanted to say something. But what could I say? Nadine? Do you know what I could've said?

Beat.

NADINE: You could've said sorry?

COLM: Do you think that would've meant something?

NADINE: No.

COLM: No. Neither did I. So I just stood there. I stood there watching her. Wondering why on earth I did all that.

Pause, COLM lost.

NADINE: Colm, they are moving against you.

COLM: Yes. But what if I deserve it?

Beat.

NADINE: What?

COLM: No, no, that's stupid, silly, sorry, I'm being a bit, I am being a bit

NADINE: Deserve? What if you –

COLM: Yes. Yes, I am. Can I… can I count on your support, Nadine?

Beat.

NADINE: Yes. Yes, of course, Colm.

COLM: And who else? Who else do I have?

NADINE: You, me, Castile. Gavin will go with a push, you won't get Ian but the four of us will be enough. That's great. This is great, Colm.

Pause.

Colm?

But COLM is a million miles away.

*　　*　　*

Board meeting.

CASTILE , IAN , CATHERINE , GAVIN , NADINE and RICHARD and the ASTROLOGER , CASTILE glaring at all of them.

CASTILE: The purpose of this meeting?

The purpose of this meeting is to establish what the fuck is going on.

IAN: I just asked

CASTILE: And I just told you.

CATHERINE: He just asked, Castile, he wasn't accusing, we're all friends here.

CASTILE: Are we? And how do friends behave towards each other?

CATHERINE: What does that mean? I have no idea what that even means.

RICHARD: Can I remind you, Castile that you are speaking to the joint CEO of this corporation?

CASTILE: You've got very big, haven't you, Richard. I remember you when you started, you had nothing in your mind but the things Colm occasionally whispered to you when he found time away from running the company

RICHARD: Don't speak to me like –

CASTILE: Is Colm dead? Did he die in the night and no-one told me? Do you wish him dead? Who wants Colm Dead? Who here wishes the death of Colm? Shall we make him gone? Lets make him gone. Lets vote him gone. Let's vote, let's vote on making Colm gone.

I call a vote. Raise your hands if you want to get rid of Colm.

They stare at him.

CATHERINE: What are you doing?

CASTILE: I'm calling a vote of no confidence in Colm.

RICHARD: Sit down, Castile, you're making a fool of yourself.

CASTILE: Constitutionally it is my right, let the record show that.

CATHERINE: This is stupid, I mean Colm will, he'll be here any second, and –

CASTILE: I am calling a vote!

RICHARD: Ian?

IAN: He… it's his right.

CASTILE: So. Raise your hand if you want to get rid of Colm.

They look at each other, uneasy. They look to CATHERINE. To RICHARD. CATHERINE looks away. RICHARD's seems to be on the verge of something… But no-one makes a move. CASTILE glares at them. Sits.

Colm is not dead. Colm is not gone. Please do not imagine that because a lion sleeps that it has no teeth.

CATHERINE: Oh my god, it's lions and teeth now. Castile, you are so…

This wasn't a good idea.

CASTILE: Maybe not for you.

RICHARD: Maybe not for you.

Pause.

CASTILE: There are a number of points to discuss. Point one is that control of Belize has been handed over to Catherine.

GAVIN: She was successful!

CASTILE: So far, yes, and that's good, but –

CATHERINE: So far, Castile? That's a bit…

CASTILE: Point two: the performance related pay structure.

NADINE: What about point one? Don't you want to talk about point one?

CASTILE: Point two: the performance related pay structures.

CATHERINE: Which Colm brought in.

CASTILE: Which Colm brought in, yes, but you're taking things too far, you're turning everyone into savages. And what's this about culling the bottom fifteen percent?

CATHERINE: Christ, you seem to be attacking us for being more Colm than Colm.

CASTILE: But fifteen percent?

GAVIN: Don't worry, Castile, you're a board member, you're exempt.

They laugh.

IAN: When was the last time you made a sale, Castile?

They laugh.

CATHERINE: Castile's Colm's boy, he doesn't need to justify his existence like the rest of us mere mortals

CASTILE: Three: general obstruction and hostility towards me, in carrying out my duties as the representative of –

CATHERINE: Oh for heaven's sake, what is he saying now?

GAVIN: What are you saying now, Castile?

CASTILE: Don't think I don't see it! I'm talking about calls ignored, emails ignored, memos ignored. I'm talking about you, Catherine, knowing that I've been trying to talk to you for days, seeing me coming down the corridor and ducking into the ladies, you, when you –

CATHERINE: Oh my god. This is insane. I needed a wee!

IAN: What about you? You didn't even reply to my mail about this meeting.

CASTILE: Two can play at that game. If you think I'm just going to –

RICHARD: Where's Colm?

Pause. They all stare at Castile.

Where's Colm, Castile? Is Colm coming?

CASTILE: Colm… has important business that he can't get out of.

Pause. They stare at him

GAVIN: Colm's not coming?

CASTILE: I am here as his… Colm is here though me.

CATHERINE: What business keeps Colm away from the board meeting that Colm called?

No answer.

RICHARD: So… you're here on your own?

Castile? All on his little own?

CASTILE: What... What's your point?

RICHARD doesn't answer.

I'm not scared of you, Richard.

RICHARD: No-one speak to Castile.

Pause.

GAVIN: What?

NADINE: What you want us to... just not speak to...

RICHARD: Do you have a problem with that? Nadine?
Fucking, Nadine?

NADINE doesn't answer, can't.

Castile has got ahead of himself. Years of service to
Colm has left Castile thinking that he is Colm. Castile is
threatening us. Castile is accusing us. No-one is to speak to
Castile.

CASTILE: This is childish. You really think...

Catherine? Ian?

They don't answer.

Nadine? Nadine?

NADINE looks at the others. She doesn't answer.

CASTILE turns to RICHARD.

What's this to going to prove? I'm not scared of you.

RICHARD: Yes. And that's a very serious mistake.

Beat.

I vote we remove Castile from the board.

CASTILE: What?

CATHERINE: Seconded.

CASTILE: You can't –

RICHARD: All those in favour?

CATHERINE and RICHARD raise their hands. Pause. Suddenly NADINE's hand shoots up. CASTILE is stunned. IAN and GAVIN follow.

Carried.

CASTILE: This is…

RICHARD: Shhhh. You're not a board member. You can't speak here.

Ian? What are Castile's targets like?

IAN: Sorry, what do you mean?

RICHARD: Well, he's a salesman. What are his targets like?

IAN: But… Castile doesn't sell. He hasn't sold in eighteen years.

RICHARD: So he's in the bottom fifteen percent, then?

IAN: Well, yes, technically, but –

RICHARD: Catherine?

They exchange a look.

CATHERINE: You want to do this?

RICHARD: Don't you?

Beat. CATHERINE buzzes an intercom.

CATHERINE: Send Security up here, please.

Takes her finger off the intercom. Looks at CASTILE. The others are stunned by the speed at which things have happened.

RICHARD: I love Colm. I will do anything, anything to protect Colm. I will lay down my life. I will kill to protect Colm.

I will kill you, I will kill you, I will kill you, I will kill all of you to protect Colm.

I'm tired of waiting for everything I do to be approved. This company is stalled. What CEO has to have things signed off like a schoolboy getting their homework approved? How can I work like this?

Beat.

GAVIN: But, it's just a failsafe, Richard, just to ensure –

CATHERINE: Do you think he needs to be watched?

RICHARD: Like some sort of cunt?

CATHERINE: Are you calling him a cunt?

GAVIN: No, no, I'm not calling him a

CATHERINE: So you think he doesn't need to be watched?

GAVIN: Yes, yes, of course, I

RICHARD: Does anyone here think I need to be watched?

Silence.

CATHERINE: Does anyone here think I need to be watched?

Silence.

RICHARD: I propose that decisions no longer need to be signed off by Colm.

CATHERINE: I second it.

RICHARD: Those in favour?

RICHARD and CATHERINE's hands go up. Beat. Then NADINE's. Then IAN's and GAVIN's.

Approved.

He sits.

CASTILE: You think that's gonna be it? You think that's the
end of it?

RICHARD looks at his watch.

RICHARD: Don't say anything. Let's just wait for Security.

<p style="text-align:center;">* * *</p>

JIMMY in a nightgown. BETH fully clothed, coat on, soaked.

BETH: What have you done?

Beat.

What have you done?

No answer.

Eight men. Eight men kidnapped, they've been, straight
away, as soon as they landed, why? Eight men have
been… where was the Security? Where was the extra, you
said, you said there would be extra, where was it, There
was nothing just…

You said there would be Security, you said –!

Pause.

JIMMY: You're wet. Would you like some tea?

BETH: Fucking tea?

I've been on the phone all day. I'm losing my job, there are
journalists outside my house, my Husband is, he is falling
to pieces, he can't take this, I've watched him crumble all
day, he's breaking down, he's weeping, they are blaming
me, fucking tea?

JIMMY: Yes. Sorry, sorry about the journalists. The press have
moved very fast, they jumped on Catherine. She was in
control of Belize. And of course she had to throw them
something and she threw them… you. Much good it'll do
her.

Our public relations have said that you, well you insured us. You did reports, surveys, you insured us, gave us the go ahead. You, Beth.

She stares at him.

BETH: You sent them out there. You sent them out there with no extra provision? Where is the extra provision?

JIMMY: There was no extra provision. There was never any extra provision. We kept those monies. I diverted those monies. I put those monies into other projects, there was never going to be extra provision.

BETH: What?

JIMMY: I'm sorry. I'm so sorry, Beth. And yet another part of me just isn't. A part of me is saying 'good, fuck you and the way you breathe. Fuck you and your beautiful hair. Fuck you and the smile that you have only ever smiled to me three times but each time it was like being washed in light' and yet I'm dying, seeing you like this. I've been crying. I've been crying today, Beth. Crying and smiling.

BETH: Why?

It makes no sense. The whole project's collapsed. Eighty million has been wiped off your share price this afternoon. Why?

JIMMY: There were… internal reasons.

Beat.

BETH: What?

JIMMY: My father says that if you can't be a warrior with every single aspect and particle of your being then you can't be a warrior. He says that real men turn their weaknesses into weapons.

BETH: Internal reasons? What internal reasons?

JIMMY: The battle has become

internal.

Pause.

BETH: I'm going to come clean. I'm going to tell them. I'm going to tell them what you said. Call your people right now and tell them that they have to come up with something else or I will tell everything.

He stares at her. Stands. Goes to the phone. Picks it up. Dials.

Waits.

JIMMY: Danny? Yeah, it's me. I'm afraid we're going to have to pull the funding. All of it. Right now. The treatment centre will close? That's terrible. When? Well, we're going to pull it now, so... Yes, I know you're committed to the expansion. Yes, I know every penny you have is tied up in... When would they be out on the streets? So soon? That is bad. Am I sure? I'll just check.

Puts a hand over the mouthpiece, talks to BETH.

What do you think?

What do you think?

No answer.

Beth?

No answer.

Beth?

What do you think, Beth?

She says nothing. Looks down.

He goes back to the phone.

Forget what I just said, Danny, everything's fine. Yeah, my mistake. Sorry about that. Have to go now. Talk to you about it tomorrow.

Hangs up.

BETH: Please. I'm going to lose my job. My Husband, he's not… you've no idea what he was like before, you… his studies, they keep him, you know, they sort him or something, you have no idea what he was like. He's falling to pieces. I can see it. Please help. Please help me.

JIMMY: Why? Why should I?

Beat.

BETH: Let's go to bed.

Do you want to go to bed? We can go to bed.

Stop this. Please.

JIMMY: If I stop this we'll go to bed?

BETH: Yes.

JIMMY: Just the once? We'll go to bed just the once?

Beat.

BETH: More than once.

JIMMY: How many times?

BETH: Many times.

JIMMY: We'll go to bed many times?

BETH: Yes.

JIMMY: We'll have an affair?

BETH: Yes.

JIMMY: You'll be mine?

BETH: Yes.

JIMMY: Body and soul?

Beat.

Body and soul?

BETH: Yes.

JIMMY: You'll love me?

BETH: Yes.

JIMMY: You'll fall in love with me?

BETH: Yes. I will fall in love with you.

Beat.

JIMMY: Which is what I want more than anything in the
world.

JIMMY suddenly sags, sits again, but heavily.

Except strength.

I understand now what strength is in this world. It's
terrible.

You'd better go. Your Husband needs you.

BETH: Jimmy… please…

JIMMY: No.

<center>* * *</center>

RICHARD, GAVIN and JIMMY. COLM enters. He carries a hold-all.

GAVIN: Hello, Colm.

He doesn't answer, doesn't seem aware of their presence.

Colm?

COLM looks up. Stares. Pause.

What's in the bag, Colm?

COLM looks at the bag as if for the first time. Looks up again.

COLM: I've killed a cat, Gavin.

GAVIN: You've…?

COLM: I've killed a cat.

> I was driving here. I love driving and I never get the chance to drive, I can't remember the last time I drove and I said to Mario 'I'll drive' and he looked at me and he said 'Don't drive.'

> *Beat.*

> And so I was driving here, thinking about what Mario had said, because it disturbed me, it disturbed me deeply and I hit something. And I got out, I mean my heart it was, I got out and went up to this shape in the dark, this cat. Just lying there. Perfect, you couldn't see any mark. And it was alive, it was watching me, but not moving a muscle, just it's eyes calmly following me. It was the strangest thing. And I went to the boot. And I took out a bag I have for my gym stuff, and I took my gym stuff out of the bag. And I put the cat in the bag. Very gently.

> And I'm driving here and the cat is on the passenger seat, sitting there in the bag, looking at me. And I'm thinking, you know, after. After I'm going to take this cat to a vet and make sure it gets well again. And all the time the cat's watching, very calm. And I get to this building. And I go in, with the cat in the hold all, because it didn't seem right to leave this cat in the…

> And I'm in reception and the cat's alive.

> And I go up to the lift and the cat's alive.

> And I'm in the lift on my way up here and the cat's alive.

> And I'm walking down the corridor and the cat's alive, I reach the door and the cat's alive, I put my hand on the handle and the cat's alive, I open the door and the cat's alive.

> I walked over the threshold into this room and the cat's dead.

It's dead, Gavin.

Pause.

GAVIN: Have… have you looked?

COLM: No. But I know.

He puts down the hold all. Takes out the cat. It is dead. He offers it to GAVIN.

It's still warm.

Not knowing what else to do, GAVIN takes the cat.

GAVIN: Catherine has presided over a disaster. Eight men kidnapped, millions wiped off our share price. Richard is assuming complete control.

COLM sees JIMMY.

COLM: Oh no. Oh no, Jimmy, don't tell me this is you, you did this, don't tell me… this is not you, no, no…

RICHARD: Jimmy… is a good boy.

Beat. COLM falters, stumbles. GAVIN goes to help him.

Leave him!

Leave this sack of shit and bone. What does he have? Who is he? Without the things we gave him. Without the respect and fear we gave him he's just a sack of shit. A sack of shit and bones.

COLM: Those men are going to die. You did this? What have you done?

RICHARD: They were insured.

RICHARD leaves. Pause. COLM goes to GAVIN. He reaches out his hand to touch the cat.

COLM: Still warm. You can feel it. Except in the extremities, you can feel the extremities getting cold.

He takes the cat back. Puts it in the bag, hugs it to his chest.

GAVIN: You're out. Sorry, Colm.

He leaves.

COLM: If there was one thing in life you could hold on to. You know? One thing, just, just one, just one and it wouldn't have to be a big thing, like maybe a feeling, or a smell or a card that someone gave you or a stone or something.

JIMMY: You said I wasn't strong. You said I lacked strength. But I have shown you what strength is. I am showing you what real strength is.

COLM: I have made this. Have I made a nightmare? I've made a nightmare, haven't I. Oh god, Jimmy? What have I made you? What have I –

Suddenly, JIMMY punches him in the face. COLM staggers back, shocked. He reaches up and there is blood on his lips. JIMMY almost seems to be waiting for something, but when it doesn't happen he walks towards COLM, slowly. Pulls his fist back again, but slowly, deliberately. COLM watches. JIMMY punches him again, COLM collapsing onto the floor. JIMMY looks down at him. Moves to him, COLM trying to crawl away, but failing. JIMMY helps him into a kneeling position, then takes COLM's right arm, COLM staring into his son's eyes, but not speaking. JIMMY places the arm below the elbow across his knee. Applies pressure, leaning, pain hitting COLM.

The arm snaps with a cracking sound. COLM screams out, absolute agony. JIMMY steps back. COLM tries to gather himself, looks up at his son. JIMMY takes the other arm, placing it across his knee. About to apply pressure.

I'm so sorry. I am so, so sorry.

JIMMY freezes. Stays there. Straining. Can't push.

Suddenly JIMMY walks out, without snapping the arm.

COLM reaches for the bag, hugs it to his chest, hugs it into him.

Second Act

A hillside, late evening, dark. Soldiers, Militia, noise.

JIMMY led in by more soldiers, not a prisoner but not treated gently. A chair is brought. GAVIN enters, stands one side of the chair. RICHARD enters with the ASTROLOGER (who stands on the other). RICHARD sits. Sudden quiet. RICHARD stands.

RICHARD: The conflict with Catherine is not over.

> She spreads hate about me, she spreads venom against me, she spits poison at me and my leadership – she lies to the North with a small force and the traitor Ian and together they defy the legitimacy of my place as rightful leader of Argeloin by not bending to my will.

GAVIN: Hello Jimmy.

RICHARD: We have chased and chased, and she has depleted the land of supplies as she has gone before us, she has supplies and we do not, she lies before us, breathing, in defiance of my will.

GAVIN: She's been very clever. We're over stretched. We have a superior force but we're overstretched, supply lines and what have you, we're running out of food. And now she stops, so the place of battle is of her choosing too, very, very clever.

JIMMY: Why don't you attack?

GAVIN: Good question…

RICHARD: I'm waiting for a sign.

GAVIN: … and there's your answer.

> Essentially what we would like you to do is to stay on Catherine's side.

JIMMY: What? She'll kill me.

GAVIN: We think she won't. She hasn't yet, so we think she mustn't know that you're with us. We think –

JIMMY: You think?

GAVIN: We think this could be a very useful position.

JIMMY: I... I don't want to do this.

RICHARD: You'll do what I fucking tell you.

GAVIN: There is either Richard or Catherine. Or oblivion. Surely you don't want to go back to oblivion, Jimmy?

JIMMY: You want me to betray her again?

GAVIN: We'd like to settle this amicably. We'd like her to see sense.

RICHARD: We'd like her to die.

GAVIN: Or just see sense. We'd like to have you in there with her.

JIMMY: I'm her lover. We make love.

GAVIN: We'll get word to you with the details nearer the time. But essentially when battle does come we'll send a force to confront yours. She'll be expecting you to defend, but instead you'll unite with our force and round on her. She'll be devastated. We'll win. She'll see sense. She'll see it's for the best. I'm sure we can wrap this up without... mess.

JIMMY: How many more times do you want me to betray? When can I stop?

RICHARD: Never. Cunt. When you're dead. Cunt. This is it and you're in it now.

GAVIN: You chose this, Jimmy. This was what you wanted.

Pause.

JIMMY: When I walked away from my father I felt nothing. I just felt... nothing.

84

Is this what you feel like? Like this? Why do you fight so
hard to feel like this? Maybe my father was right. Maybe
I don't have this in me, maybe I'm lucky not to have this.
I feel sorry for you. I look at you and I feel sorry. But now
I'm like you, so how does that work?

*RICHARD stares at him. GAVIN stares at him. Beat. RICHARD walks
past JIMMY, pats him on the back.*

RICHARD: Never mind. It's fine. That's fine.

Moves behind JIMMY. Takes a gun from a soldier. GAVIN sees.

GAVIN: I strongly advise that you begin to understand that
things have changed. I strongly advise that you see this is
a different time. Do not reject the realities of this time as it
is the logical conclusion of previous times and I strongly
advise you to begin to understand that. Now.

RICHARD is behind him, raises the gun.

JIMMY: Is this who I am, then? Now?

Alright, I'll do it.

*RICHARD stands there gun raised. Almost seems to be considering
doing it anyway. Suddenly GAVIN hugs JIMMY.*

GAVIN: Well done! Well… done.

*RICHARD lowers the rifle, heads back, puts it down. GAVIN starts
to take JIMMY away.*

You should take some comfort in the fact that you have no
choice. Catherine doesn't know what you've done. But if
you don't do what we ask then she will. You're on our side,
whether you like it or not.

GAVIN shows him out. RICHARD turns to the ASTROLOGER.

RICHARD: You still want me to wait?

ASTROLOGER: Saturn is retrograde. Have you noticed? Can
you feel it? But you must strike at the right time. Wait until
the right time. Wait for the sign.

RICHARD: My men are starving.

ASTROLOGER: Why do you bother me with unimportant facts? The stars are speaking to you, please listen. They don't like to shout.

RICHARD: Will I win?

ASTROLOGER: Probably.

You have committed a great many crimes. Is that right is that wrong? Who cares? The real question is have you committed enough? Saturn is retrograde. Your greatest crime will destroy you, unless you destroy it first. You can't do things by halves, dear. In for a penny…

RICHARD: You once said be careful who I trust – does that mean I can trust you?

ASTROLOGER: Yes. You can trust me. You can always trust everything I say. Our fates are bound together. You can always trust everything I say because the moment I lie to you will mean my end.

RICHARD: Fucking tell me who my greatest crime is! Tell me now.

ASTROLOGER: *(She recoils.)* Oh. I can smell your fear from here. It's repellent.

RICHARD: You know I could ask anyone of these men to put a bullet in your eyes.

But she just laughs and moves away, genuinely amused. RICHARD goes to follow but GAVIN enters with BETH. She looks completely different, lost, not of this world, but for a moment RICHARD doesn't notice her, his mind racing.

(To GAVIN.) You. Find me Colm.

GAVIN: What? But Colm's not important anymore, he's –

RICHARD: Find me Colm.

Beat.

GAVIN: This is Beth.

RICHARD: Gavin says you've lost everything.

BETH: What?

RICHARD: Gavin says you've –

BETH: Things which I gone, things, yes, gone, things, my
Husband, we had some life or other, some form of life or
other and he found discrepancy, or some such other word
which escapes me now, but yes, betrayed or some such
other thing which, this thing, this force, this dark force
which some such force or other came and upon me, sat
upon me my life until the breath left its lungs, expiration.
Gone. Dead. Father dead, Husband dead, despair. Dead.
Life dead, I would like

Beat.

satisfaction.

RICHARD: You would… like satisfaction?

BETH: Yes.

RICHARD: Revenge? Revenge on Jimmy?

*The name hits her like a tidal wave, but only on the inside, on the
outside she barely registers it.*

BETH: Yes.

Pause.

RICHARD: Does she always talk like that?

GAVIN nods.

You are beautiful because you have been snapped in two
and you are still moving. Will you do anything?

BETH: Yes.

Beat. He considers. Pulls out a pistol.

RICHARD: See this gun?

BETH: Gun, yes.

RICHARD: Have you ever used one?

BETH: No.

RICHARD: This is the safety. Pull back to this position, point, pull the trigger.

She nods. He puts the gun back in the holster, takes the holster off, throws it to the ground. Steps back. Points at GAVIN.

RICHARD: Use it to kill him.

GAVIN is stunned, but without a second's hesitation she begins to pick up the holster and extract the gun.

GAVIN: What…? What the fuck, Richard, what the…?

She has the gun out, works the safety.

No, look, Jesus, alright, you've made you're point, so let's –

She points the gun at GAVIN s face.

No!

She fires it repeatedly, but it is empty. She fires it again and again and again, GAVIN terrified of every click. She continues to fire the empty gun until RICHARD takes it from her.

She just stands there.

RICHARD: Perfection.

* * *

Countryside. Early morning. CATHERINE and IAN enter.

CATHERINE: Right. Okay.

What, here? He's…? He's just…?

IAN: Yes.

CATHERINE: Right. Okay. Shit. What does he want?

IAN: He wants to see you.

CATHERINE: He wants to see me?

IAN: Yes, he wants to see you.

Silence.

Catherine?

CATHERINE: What's morale like?

IAN: Not great.

CATHERINE: He's Colm's son, you see. Morale, I mean he'd be good for morale, legitimacy or, you know…

Do you think he betrayed me?

IAN: I…

But he cannot finish. Long pause.

CATHERINE: Morale. He's Colm's son. You know, morale is…

IAN: Yes, yes, of course morale is… morale is…

Pause.

Catherine, if… If he has betrayed you…

Beat. She waits for him to finish.

is it wise to keep a viper at your breast?

CATHERINE: What?

IAN: Is it wise to –

CATHERINE: What? What are you taking about? Vipers?

IAN: I'm just asking -

CATHERINE: Jesus Christ, I mean where do you get this… vipers and breasts?

IAN: Catherine, I am just trying to –

CATHERINE: Look, just please stop!

Silence.

Why is Richard waiting? He's just sitting there waiting.

I mean they must be running low on supplies, and here we are, this land, you know, food, whatever, but look at them. Across there.

IAN: I… I don't know.

CATHERINE: There's something here, you see. Something in it, I can't quite…

Pause.

So you think he did or didn't betray me?

IAN: I… think he did.

CATHERINE: Right. Bit negative. There's something in it, you see, some play, some stratagem I haven't yet…

I think… I think I'm going to welcome Jimmy with open arms.

Beat.

IAN: What if he comes back and he has betrayed you?

CATHERINE: If he comes back and he has betrayed me then I have the advantage because he won't know I know he's betrayed me.

IAN: But if he comes back and he has betrayed you the reason he's coming back is to betray you again.

CATHERINE: Then I will stop that.

IAN: How?

CATHERINE: With my feminine wiles.

IAN: Are you in love with him?

CATHERINE: What?

She suddenly laughs.

Don't be such a fucking idiot, you –

Where did you learn to be such a fucking –

Why are you such a fucking –

Suddenly JIMMY shows up. They stare at each other. She throws herself at him, hugs into him. He returns it. They hug, both desperate for it. IAN watches. They pull back, kiss, pull back.

My love…

JIMMY: My love.

CATHERINE: My… fucking love.

*　　*　　*

A room, small, very basic, packed with stuff, junk. BARBARA stands, CASTILE has just come in. COLM lies unconscious on a tatty couch. Shows CASTILE to COLM. CASTILE goes to him.

BARBARA: He just, he just came here. I don't know why, he
　　just turned up at my –

　　I found your number. In his pocket. I wanted to call,
　　nothing works these days, so it's taking me ages, ages to
　　find a working –

　　Careful!

Castile stops.

　　His arm. It's broken.

CASTILE: Is it?

BARBARA: Yes. I set it. I think it's a clean break. I mean I don't
　　know, but I think it is. I think it'll heal. Probably.

CASTILE: Thank you.

BARBARA: Do you know him?

CASTILE: I know him.

 Do you know him?

BARBARA: No.

CASTILE: Why did he come to you? Have you met?

BARBARA: No, never.

CASTILE: Then why did he come to you?

BARBARA: I don't know, I don't know why he came to me.

CASTILE: Did he say anything?

BARBARA: Just ramblings, he just rambled, like rambling on and on.

CASTILE: You've looked after him. Thank you.

BARBARA: No, I mean I couldn't just… I mean he's, I couldn't just –

 My daughter!

CASTILE: What?

BARBARA: That's what he kept saying, he kept saying my daughter, he kept calling me his daughter. He thinks I'm his daughter. Do I look like his daughter?

CASTILE: He doesn't have a daughter.

BARBARA: Oh. Right.

 I didn't want to let him in. I mean I haven't got much, you know, and I saw him and I thought, I mean he needs, stuff. Food and… And I haven't really got much, but you have to feed, sustenance, he needs… so I've been feeding but it's not easy because he doesn't want –

 Castile gets up and goes over to her. Takes out his wallet.

 What are you doing?

CASTILE: *(Pulling out cash.)* Compensating you.

BARBARA: What?

CASTILE: You have no need to worry, you will be adequately
compensated for –

She slaps the money out of his hands. He is shocked. Silence.

BARBARA: Fuck off.

Fuck off, alright? With your money and, who do you think
you are?

CASTILE: I was just…

BARBARA: This is my house, okay? coming in here, in here,
with your money and your suit and your fucking suit like a
tramp, actually, I don't get bought.

CASTILE: No, no, I didn't mean

BARBARA: This is my house, you can take your money, I don't
want your –

He bends down to pick the money up.

Leave that.

Leave that now, I'll have that now, on the floor, but don't
come in here with your, don't you try that again, alright?

CASTILE: I'm sorry

She picks up the money.

BARBARA: Yeah. Well. Okay, but…

CASTILE: I wanted to say thank you.

BARBARA: Well just say thank you.

CASTILE: Thank you.

BARBARA: You're welcome.

(The money in her hands.) Useless now anyway.

CASTILE: He's an important man. People are looking for him.

Beat. She looks at COLM, doubtfully. She indicates the gym bag.

BARBARA: He had that with him. It's got a dead cat in it.

He looks at her.

Yeah I know.

CASTILE: Are you… Is there anyone else here?

Family or, a mother, a father…?

BARBARA: All dead. Years ago. My mother last. A long time ago, though, so…

CASTILE: I'm sorry.

BARBARA: Yeah.

CASTILE: I can't move him.

She stares at him.

I've nowhere to take him. You've been so kind, you really have. He's an important man. I believe he might be able to stop all this, but I need time, he's important, people will be loyal to him and if I can just contact –

BARBARA: See you're worried about him then.

Pause.

Right. Right. So you can't… shit.

So you're not gonna… Right. Right.

Beat.

CASTILE: What's your name?

BARBARA: Barbara.

Beat.

CASTILE: What?

BARBARA: Barbara, it's Barbara.

He is staring at her.

What?

CASTILE: No nothing, no reason. I just… knew, knew of someone with that…

BARBARA: What's his name?

Pause.

CASTILE: What?

BARBARA: What's his name?

CASTILE: Him?

BARBARA: Yes.

Beat.

CASTILE: Bob.

BARBARA: Bob?

CASTILE: Yeah, he's called… Bob.

Beat.

BARBARA: Bob. That's nice. You don't meet many Bobs these days do you?

CASTILE: No. No you don't.

BARBARA: No, I like that. Bob.

*　　*　　*

BETH on the hillside, RICHARD sits watching. It is as if BETH is trying to do something but isn't. RICHARD, fascinated. She seems unaware of him even though he is close. Back further is the ASTROLOGER, watching them both. Suddenly she stops. Silence. RICHARD waits. ASTROLOGER waits.

She pulls a peach out of her pocket, raises it to her mouth. Stops. She is overwhelmed with something, but it is gone almost instantly. She continues to try to get the peach to her mouth.

RICHARD sits in front of her, makes eye contact. Finally she looks at him.

RICHARD: My name is Beth and I am eating a peach.

Beat.

BETH: With what intention within, in which some destruction finds.

RICHARD: No. My name is Beth and I am eating a peach.

BETH: Fragments of, exploding, disintegrating, into plumes of pain, agony, screaming frivolous devastation with cuts and cuts and cuts –

He grabs her arm.

RICHARD: My name is Beth and I am eating a peach.

BETH: I… which land thereof contains a soul crushed in a… peach.

RICHARD: Peach, yes. My…

Beat.

BETH: My…

RICHARD: Name is Beth.

BETH: Nam ee Bet.

RICHARD: And I am eating a peach.

BETH: And…

GAVIN enters, furious. NADINE in tow.

GAVIN: Ask her why she –

RICHARD holds up a finger for him to wait, but still remains entirely absorbed in her. GAVIN holds his tongue.

BETH: …and, and, and… I am crushing my love with broken limbs.

Beat. RICHARD lets go, sits back. She begins to eat the peach.

GAVIN: Ask her what she's done. Ask her! Two men in Nadine's command were accused of stealing food. Okay, right. Punishment, yes. But this creature, this pet of yours, storms in with her fucking boys, with –

RICHARD: You mean my bodyguard.

GAVIN: I mean with her fucking animals! She storms in and takes them. Ask her what she did. Ask her!

RICHARD: I can't ask her, she doesn't understand, just tell me.

GAVIN: They took them into the woods. Hacked them to pieces. With mattocks, rakes, implements, farm implements, they cut them into chunks of meat, they decorated a tree with their guts. Then, Richard, then, she goes back to the storeroom they were accused of raiding and sets light to it, sets light to the food, to the fucking food, Richard!

RICHARD: She did that? Beth did that?

GAVIN: Yes! When you gave her control of the bodyguard I said nothing. When you put her in charge of camp discipline I kept quiet, but this?

NADINE: Look, Richard, I know this is not my place, but I have to say something, I mean look; the men are… We have to attack. We have to attack, Richard, the food is running out, she's destroying food, we're sitting here, the men are getting, we have to do something, we –

RICHARD: Do I look different? Nadine?

Pause. She is thinking, hard.

NADINE: Yes.

RICHARD: How?

ASTROLOGER: Mad. You look mad.

RICHARD ignores her, keeps his eyes on NADINE.

RICHARD: Last night as I lay in bed, the window open I began to sweat. Despite the fact that it was a cold night I began to sweat. And it was the sort of sweat that stings you, across your forehead perhaps, but this was across my entire body, my face, my arms, my toes, my anus, my scalp, everywhere, it felt as if my skin was burning, do you understand? But a good burning, it felt like my skin was burning a good fire that was incinerating the outer layer of my body.

And as this went on, as this good fire burnt the flesh from my body, I became convinced that the room was becoming brighter. Almost imperceptibly brighter, but it was perceptible because I perceived it, I perceived it becoming imperceptibly brighter. And then I noticed that at the end of my bed sat a small squirrel. Just sitting there, watching me. A small squirrel had come in through the window, climbed over my dresser, crossed my floor, up the leg of my bedstead and now sat there looking at me, looking at me sweating a good fire in that imperceptibly brightening room.

And I was not afraid. I showed no fear.

Because fear was no longer in my body, do you understand? I no longer have fear.

And because I showed no fear the squirrel was joined by friends. Other squirrels. Slowly at first, cautious, yes, popping in through my window, but more and more, with more confidence, and they were joined by other woodland creatures; rabbits, pigeons, badgers, field-mice and voles, songbirds, thrushes, chipmunks and hedgehogs, even earthworms and ants, all manner of woodland creature including an antelope came into my room to sit and watch me.

Pause.

What do you think of that?

She has no idea what to say. Thinks hard. Suddenly she kneels.

NADINE: I kneel before divinity!

RICHARD: Do you?

NADINE: Yes. I do. Yes I fucking do.

RICHARD: Come to me.

Beat. For a second she is unsure, then she goes to him. He indicates that she should sit on the ground at his feet. She does so and he looks back up at GAVIN, stroking her hair.

Society is a type of madness. The trick of being successful in any given society is to promote the kind of madness that is most profitable to your desires at that time. Beth is a genius.

Where's Colm? I asked you to find Colm.

GAVIN: I… I have information, I think I know where he is, I have, someone, someone who can tell me, information about…

RICHARD: Will you kill him for me? I want you to kill him for me.

Beat.

GAVIN: I… I thought you just wanted me to find –

RICHARD: Things have changed. Something's coming. Can't you feel something coming? I need Colm gone before it gets here. Kill him for me. Go on. Go on, please. You're my only true friend. I love you. Kill Colm for me, please. I want you to kill Colm. Do you have a problem with that?

GAVIN: No. No, I don't.

Beat.

RICHARD: Beth is genius. We must all learn from Beth.

They watch her finishing her peach. She looks at the stone. Tries to eat it.

*　　*　　*

Barbara mixing food. Goes to COLM, sits him up, starts feeding.

BARBARA: Come on…

He is practically unconscious, but his eyes are open. She pushes his top half up she can sit on the couch. She gets the spoon with the food to his mouth, but his head sinks down onto her lap.

No, look, don't…

But his head is now on her lap. Sighs, tries feeding him again.

Eat.

Again.

Eat!

But he is unconscious. She holds his nose. His mouth opens. She feeds food into his mouth with a spoon. Waits for him to swallow. He holds it in his mouth for a while, then slowly pushes it out.

Bob!

She begins to try and scoop the food back in with the spoon, but too much is coming out. The spoon is no good, she uses her fingers. Suddenly COLM is sucking the food from her fingers. She is shocked. He eats all the food from her fingers, goes still. She thinks.

She uses her finger to mop the food around his mouth into it, and he eats it all until her finger is clean. She begins to finger the food from the bowl into his mouth, COLM sucking the food from her finger and eating it. This goes on for a while.

CASTILE enters, unseen. Watches. Suddenly she becomes aware of him, stands, shocked, like someone caught in the act, COLM's head falling from her lap. She stares at CASTILE.

Porridge. He… he likes porridge.

Beat. CASTILE gathers his things. She watches. He has everything. Pause. Turns to her.

CASTILE: I've got to go.

War is coming. Battle is a breath away, you must be able to feel it? But there are forces within those forces who will unite behind him, do you see? Now, I have made contact with certain people and they will…

BARBARA: I knew you were useless as soon as you walked in the door.

Beat.

You know that? I looked at you with your money and your suit and your I rule the world and I thought 'what use is he? What actual and physical use is he? What can he actually do?'

CASTILE: It's not like that, he's important, we can stop this, he can –

BARBARA: Go on then, fuck off. Fuck right off.

Beat. CASTILE leaves. Silence. Then COLM curls into her, like a cat. She gets the food and begins feeding him again. With her fingers.

* * *

Night. CATHERINE and JIMMY, hand in hand, wandering. She stops.

CATHERINE: This is where we shall fight.

I shall be in the centre, here. Ian shall take the west, along the tree line to the sea. And then beyond that ridge, to the east there, is the high ground. The high ground is my weakest and strongest point. If they were to take the high ground they could move onto that ridge. And if they take that ridge… well, the battle's lost.

Pause.

Do you know what I feel when you say that you loved her?
I feel a pain like you can't imagine, like a piece of metal,
a piece of ice cold metal has somehow materialised inside
my chest, into the place just under and slightly to the back
of my heart. And maybe the metal is not metal, because
it runs out into my veins, so maybe it's liquid metal, yes,
liquid metal suddenly runs through my veins and into
my capillaries and it freezes, you see, and I am like a
skein of tendrils of frozen metal so that if you hit me with
a sledgehammer I would shatter into a thousand pieces.
That's how it feels.

*She sits on the grass. Invites him to lie in her lap. He hesitates, then
does so. She strokes his hair. Silence.*

JIMMY: I don't know what I feel when I'm with you. I'm
not sure if I'm alive. I'm not sure if I don't feel that I'm a
corpse, a living corpse in the arms of another living corpse.
But I don't want to leave. I want to rot with you. Is that a
good thing? I must love you. Mustn't I?

CATHERINE: I think it's going to be tomorrow. I think this
is our last night like this. Look at those stars. I'm going to
give you the high ground.

Beat.

Ian thinks you're going to betray me. 'You have such a
dark view of human nature', I said, but that's not true at all,
he's really quite… rosy. I think he might be right. I think
you might be about to betray me.

JIMMY: Then… then, why are you giving me the high ground?

*She smiles. Slowly she take out a knife. She gently but firmly grabs
JIMMY's hair with one hand and places the tip of the blade to his
jugular with the other. He freezes.*

CATHERINE: When I first saw you I thought 'Look at that
boy, that silly, gangly boy. Look at that silly, gangly boy.'
You were so awkward and… silly, and I looked at you and

you moved to scratch yourself or something and my heart broke. Do you love me more than her?

Pause.

JIMMY: Yes.

CATHERINE: I'm showing you my faith in you. I'm giving you everything. So that you know, if you were going to betray me, who I am and what I feel. So you could just betray him instead. The choice is yours.

JIMMY: I did such a terrible thing to her. I wake up and I see her, I see her weeping.

What are you going to do? Are you going to kill me?

CATHERINE: No. I'm going to bind us to each other, because I believe we have a thing that is love, or the shadow of love, or even love, but I want it to be deeper and more agonizing, so I'm going to bind us together.

We're going to sleep out here tonight.

JIMMY: It's freezing. It'll be well below zero, it's... We'll freeze to death.

CATHERINE: Lets wrap ourselves around each other for heat. Lets pull ourselves into each other so that it becomes the only way we can survive, so that the only way we can possibly live through this night is to cling to each other with every fibre of our beings.

JIMMY: We'll die.

CATHERINE: Probably.

Slowly they lay down together, face to face, entwining completely, CATHERINE keeping the tip of the knife to him, so that eventually she is holding it to spine at the back of his neck.

JIMMY: Are... are you keeping the knife?

CATHERINE: Yes.

JIMMY: We might die.

CATHERINE: We might. But imagine what we'll be to each other if we survive.

JIMMY: Oh god. Is this what it's like to be you?

CATHERINE: There, there. My silly boy.

JIMMY: Oh god.

CATHERINE: My silly, gangly boy.

* * *

RICHARD in a woods. Waiting, looking at the sky.

Suddenly there is a meteor shower, very, very beautiful.

The ASTROLOGER enters.

RICHARD: I don't have Colm.

ASTROLOGER: Now is the time.

Pause.

Just do your best, dear.

* * *

Soldiers. RICHARD, GAVIN, NADINE, looking over a map.

GAVIN: They've formed a line across the hills in the east to the sea in the west. Ian has the west, Catherine is in the Centre, with the bulk of their force. But Jimmy's has the east.

It's a good plan. Ian has the sea so we can't go round him and Catherine can use the town as cover. And Jimmy has the high ground. Even then there's the ridge between the centre and Jimmy, so if he looked like he was losing the high ground, well, there's the ridge, they re-enforce the ridge. It's a good plan.

Except if they lose the ridge. Then it's a shit plan. Then we'd come down on them and push them into the sea. The ridge is the key, if we get over that ridge, then –

RICHARD: We attack from the south.

Beat.

GAVIN: They're strongest from the south. That's where Catherine is. If we go east we can unite with Jimmy on the high ground. From there –

RICHARD: We attack from the south.

Pause.

GAVIN: Whose plan is this?

RICHARD: Beth's. It's Beth's plan.

GAVIN: Beth doesn't know that Jimmy is on our side. And, well, pardon me for saying this Richard, but she is actually insane.

RICHARD: She's plugged into the universe.

NADINE: It's a great idea. That's a fucking great plan.

RICHARD: We attack from the south. They'll hardly believe their luck, they'll put all their strength into the south, they'll imagine they can cut us to shreds. Then we shall come down on them. Show them in.

Beat. GAVIN goes.

NADINE: Can I just say that is genius. And I'm not saying that just to butter you up, I don't know what his problem is, I mean I think that it's brilliant.

RICHARD: It doesn't matter. There was a meteor shower last night. In my sign. We can only win.

NADINE: Absolutely. Abso-fucking-lutely. We can only win. Because we have the strength –

RICHARD: Because of the meteor shower

NADINE: because we have the strength and the meteors. We
have the meteors as well, yes. Which is great. You are a
great man.

GAVIN enters with some officers.

RICHARD: A sign has been given to me from the powers that
control the universe.

Nadine, you head west and engage Ian's force, hold him
there. Gavin, you take a small force, head east like you're
going to engage Jimmy. Beth and I will attack Catherine,
full on in the front, from the South

NADINE: Brilliant.

RICHARD: and at the right moment you will unite with Jimmy,
move over the ridge, and come down on their flank.

NADINE: Yes!

RICHARD: Destroy all rations. Let the men know that
Catherine has surplus, let them know they win or starve.

NADINE: Sorry?

RICHARD: I have decided that anyone who doesn't fight well
enough will be executed after the battle. The bottom fifteen
percent. The bottom fifteen percent will be executed. And
stop looking so scared.

* * *

Sound of shelling, not too far away, getting closer.

*BARBARA is staring out of the window to get a view, but with the
curtains closed. COLM lies unconscious on the couch. He opens his eyes.
Lies there. For some time.*

COLM: I had the most incredible dream. I dreamt I was
powerful and rich with so much in my life. A family, a
house, a wife, a son, I had so many things. And then I

woke up and I was trapped inside my own nightmare, inside the things I had created and things that I had created had decided to destroy me. And I could only agree.

Beat.

I saw a meteor shower. A terrible meteor shower. Like fire raining down on us. Are you real?

BARBARA: How do you feel? How's your arm?

COLM: Are you my daughter?

BARBARA: You haven't got a daughter.

COLM: Maybe you aren't real then.

Loud shell too close for comfort. BARBARA ducks down.

BARBARA: Jesus Christ!

COLM: What's that noise? Is that my heart? Is that what my heart sounds like?

BARBARA: The fuckers are shelling the town!

COLM: Yes. They did that in my dream. With meteors.

BARBARA: Well these aren't meteors.

She watches. Shells seem further away again. Turns to COLM.

How are you? Are you feeling better?

COLM: I feel like my soul has been bathed in acid, I feel pain, I feel dry, I feel like I've lived a thousand years in a single second. Is that good? Should I be feeling that?

BARBARA: I'm gonna get you some water, do you want some water?

Pause. She goes to gets him some water.

You looked peaceful lying there. Sleeping. Looked like my dad. You know, the sofa, he used to sleep on the sofa.

Maybe that's all dads, I don't know. You smell like him. Your hair. Not really, but a bit.

COLM: *(Suddenly frightened, feeling his hair.)* Maybe this is his hair.

BARBARA: Does anything hurt?

COLM: Suddenly I feel like crying.

BARBARA: Don't cry. Don't fucking cry.

COLM: I suddenly feel this immense, you know, this immense, this incredible, but if I do, if I do, you see, it will all go, I will cry and cry and cry until I cry all of the liquid out of my body and then I'll be desiccated and the slightest breeze will blow me away.

Beat. He seems to be crying.

BARBARA: Bob?

COLM: I... seem to have liquid coming out of my eyes. Is... is that normal?

She is near him now.

BARBARA: Look, it's okay, don't worry, it's... look, drink this, you need –

Suddenly he sees her and cries out, recoils as if he had seen a demon, climbs back into the sofa as far from her as is possible.

COLM: I'm dead, aren't I? Have you come to torment me in?

BARBARA: You're not dead, Bob, you're just not well. You need to –

COLM: Bob? Is... that my name? Is... that who I am?

BARBARA: Yes. Yes it is. You're Bob.

COLM: I thought I was someone else. I thought my name was –

Suddenly a shell bursts nearby, shaking the rooms. BARBARA falls to her knees. The shelling continues, the same intensity, deafening, but all of a sudden COLM is in rapture.

BARBARA: Sit down!

Another shell, this time blowing the door off its hinges.

Bob!

COLM: This is here for me! Oh god, this is here for me!

Suddenly COLM heads for the door.

BARBARA: What are you doing? What are you –

But the shelling has become deafening. COLM flings the remains of the door open. His face glows in the fire.

Suddenly he grabs his bag and runs out. She stares after him. She moves to the door, looks out. Beat. She runs out after him.

* * *

Enormous shelling. Subsides.

An OLD SOLDIER comes on, spooked, looking around, pointing his gun at shadows. Sees something coming, hides in debris.

MARTIN enters wearing a soldier's uniform, terrified, no weapon. The OLD SOLDIER leaps out, gun pointing at the him.

OLD SOLDIER: Down, down!

MARTIN: I'm, I'm on your side, I'm –

OLD SOLDIER: Now!

MARTIN kneels.

MARTIN: I'm on your side, I'm on your side!

OLD SOLDIER: Liar.

MARTIN: no, honestly, I'm…

OLD SOLDIER: Make your peace, boy.

MARTIN: No, no, I'm on your side, this isn't, it's not my
uniform it's –

OLD SOLDIER: Make your peace with god.

MARTIN: I'm with Catherine! I am with you, your side, please!
I put this on to get away, it's dead, a dead man's uniform,
see? The, the, the blood and this hole, it's not, I haven't,
can I, can I show you?

MARTIN starts to move, slowly, starts to open his shirt.

See? Look, no hole. I'm not, hurt or, I put this on, I'm with
Ian, we were with Catherine, I've been with Catherine
for...

*The OLD SOLDIER considers him. Beat. Lowers his gun, but still
has it ready.*

OLD SOLDIER: Talk.

MARTIN: What?

OLD SOLDIER: Don't make me repeat myself, boy.

MARTIN: Right.

They, they, they just fucking, they just started fucking –

OLD SOLDIER: Calm. Breathe.

Beat. MARTIN calms. Breathes.

MARTIN: We were in the town.

We had the town so they started shelling. We pulled out,
and the civilians, we said this town is ruined, get out. You
know, in shops, coffee shops, banks, we said 'you'd better
get out' and they would nod and agree, but they just...
they just stayed. And they shelled, they shelled the whole
town. And we went back in and we'd pass the people we'd
told to get out and they'd still be in the same places, but
dead, you know like you might see someone at a counter

of a ruined bank but with the side of their face missing, or someone having a coffee but dead, burnt, blackened flesh. We waited with the dead.

They came up the street. And we were dug in so we just cut them down, your finger became tired from the trigger, but still there was more, we just cut. Piles of dead. So they shelled us. All of us. Us, them, the whole town, firebombed the town. It was madness. You had no idea who you were killing, we killed with bottles and bricks, with teeth and hands. And the corpses just watched, with their tills and coffees thinking 'who's clever now, eh?'

I woke up, alone, and my clothes had been burnt from me. So I stripped a corpse. And then this man, one of theirs, and he was really kind, he saw my fear and he helped me, he took me through the debris, rubble, through the fighting, their lines to their sick bay, and as soon as I was in the clear with him I slit his throat and ran. He was really kind.

Pause.

OLD SOLDIER: You did right. He was the enemy.

MARTIN: Are you going East?

OLD SOLDIER: Re-enforcing the ridge.

MARTIN: What? Has Jimmy lost the high ground…?

OLD SOLDIER: Hasn't lost it. Just not doing anything. Just sitting up there, men waiting, doing nothing. Catherine got scared, sent us. Just in case.

MARTIN: On your own? Where's your unit?

OLD SOLDIER: All dead.

Beat.

MARTIN: Are they back there as well?

OLD SOLDIER: They're everywhere.

MARTIN: But where's the line?

OLD SOLDIER: There is no line. Just fighting.

OLD SOLDIER opens his pack. Pulls out a cake.

MARTIN: What's that?

OLD SOLDIER: *(He looks.)* Black forest gateaux.

Found it in a cake shop. Carnage. Looked liked someone had filled a weather balloon with blood and meat and burst it in there.

MARTIN: Are you gonna eat that?

OLD SOLDIER: Cut away all of the bloody bits. Want some?

Beat. MARTIN sits with him. They clear a space in the debris, place the cake down. They stare at it. MARTIN pulls out a flask and begins to open it. Sees the OLD SOLDIER looking at him.

MARTIN: Tea.

OLD SOLDIER: Tea?

MARTIN: Yeah. Found it.

OLD SOLDIER: Fucking tea?

He pours some into the inner cap.

Is it warm?

MARTIN dips a finger in. Nods. Offers it to the OLD SOLDIER. The man takes it, MARTIN pours himself a cup and they sit there having tea and gateaux for quite some time.

Bliss.

What did you do before?

MARTIN: I was an Executive Head of Communications. You?

OLD SOLDIER: Financial advisor. Futures and Hedge funds.

MARTIN: No wonder you're so calm.

They eat.

What do you think things'll be like? After this?

OLD SOLDIER: Things'll be shit. For a thousand years.

MARTIN: Right. Cheerful.

OLD SOLDIER: S'all in the bible. We make our own hells. As ye sow, so shall ye reap.

MARTIN: Bird in the hand.

OLD SOLDIER: You taking the piss.

MARTIN: No.

Pause. They have finished eating.

Look, if we worked together, you and me, maybe we could find a way out. Out of this.

OLD SOLDIER: There is no out. Read your bible. This is the end of days.

MARTIN: Jesus Christ.

OLD SOLDIER: Yes.

OLD SOLDIER gets up.

MARTIN: Where are you going?

OLD SOLDIER: The ridge. We were sent to re-enforce the ridge.

MARTIN: No, no, what are you doing, your unit's dead, no that's stupid, that's

OLD SOLDIER: Come on.

Beat.

MARTIN: What, me?

OLD SOLDIER: Yes.

MARTIN: No. No, no, no. No way.

OLD SOLDIER stares at him.

Mayhem. That ridge is going to be mayhem. I'm not going with you.

OLD SOLDIER: Let's go.

He heads off.

MARTIN: Are you deaf, I'm not…

But the Soldier has gone. Beat. Realises he's alone. He runs off after the OLD SOLDIER.

* * *

The ASTROLOGER, humming. RICHARD enters, bloodied, fresh from battle, followed by NADINE. Lastly BETH.

RICHARD: What do you see?

No answer.

Nadine is being held by Ian, Gavin has yet to reach Jimmy and in the meantime I am down here trying to keep Catherine's attention away from the high ground, but we are being hacked to pieces, cut to shreds, what do you see?

Pause. The ASTROLOGER says nothing. Looks scared. RICHARD turns to BETH. About to speak, but…

ASTROLOGER: Don't. Don't do what you're about to do.

NADINE runs on, looks terrible. RICHARD turns to BETH.

RICHARD: Beth? Do you want Jimmy?

BETH: What? What, yes, I did something, there was something, passing over now with flayed eyes yes, yes. Please, yes.

RICHARD: He's with Catherine.

BETH: Is he? This Jimmy then?

Beat. She goes. RICHARD turns to NADINE.

RICHARD: Let her cut us a path to Catherine. Where's Gavin?

NADINE: What? He's, he's on his way to the high ground, he's… I don't know, I don't know, Richard, I don't know what he's doing he's taking forever he's like a fucking snail, he's, I don't…

Pause.

RICHARD: What? What is it?

NADINE: Jimmy. Jimmy's gone.

Beat.

RICHARD: Pulled back. You mean, you mean he's pulled back he's waiting for –

NADINE: No. He's gone. He's left. He's abandoned the field without so much as firing a shot, he's not with us or them, he's fled, he's gone.

Richard?

Beat.

Richard!

RICHARD: *(To the ASTROLOGER.)* What. Do. You. See?

ASTROLOGER: I don't want to say. I told you to look to your greatest crime!

Pause.

Your end. It's over.

RICHARD stunned. Recovers. Stares at the ASTROLOGER.

RICHARD: When you say 'your end'… do you mean our side's end or my end?

ASTROLOGER: Don't make me lie to you. Please.

RICHARD: Are you saying we will lose the battle or are you saying I will die?

ASTROLOGER: Which would you prefer?

RICHARD: Listen to me; are you saying the battle's lost or I am lost?

Says nothing. RICHARD points his gun at the ASTROLOGER's chest.

Say or I'll execute you.

Pause. The ASTROLOGER thinks. Thinks.

ASTROLOGER: The battle is lost.

RICHARD executes the ASTROLOGER.

RICHARD: She said that her end comes when she lies to me. I have brought about her end, Therefore what she has just said is a lie. I will live, we will win the day. I have made things this way.

Tell Gavin to attack the ridge. Now.

NADINE: Attack the…? Right. He's not gonna like that. I mean it's a great idea and everything, but him and Jimmy were going to do that together –

RICHARD: I have mastered the skies. Take this betrayal into your hearts, pump it like blood through your limbs. Now is the time for madness, lose sense, lose intellect. Kill all the prisoners

NADINE: Kill…?

RICHARD: then kill ten men who look weak, wipe blood on your face, find a corpse, eat flesh, eat the brains, find madness and on! On!

He runs off. She stares after him. Looks to the ASTROLOGER's Body.

NADINE: Jesus Christ.

She runs off after RICHARD.

* * *

Battle. BARBARA has COLM sat down, but he is trying to get up.

BARBARA: Bob, you just have to sit where you are okay? You just have to –

COLM: Did I make this? Tell me, please, do you know? Do we make our gods? Did I make the wrong god?

(To the sky.) Talk to me! Tell me I haven't made a mistake!

BARBARA: Bob it's okay. Some people are coming. Some people are coming to help. Bob?

COLM: I had a daughter once, no, not a daughter, I didn't have a daughter, I had a son, only I didn't have a son because to have a son you must be a father and I was no kind of father. I would ask you for a kiss if I didn't fear it might kill you. I'm praying this storm has been sent to strip me bear, my mind, my thoughts, my flesh, my possessions, my eyes, my heart and my memories, but I have a voice in this arm that screams a kind of agony into my mind and I fear that I will never be free of my sins.

GAVIN enters, armed. CASTILE comes after. BARBARA sees them, but is wrapped up in COLM. They watch.

You are so… What's your name?

BARBARA: Barbara. My name is Barbara.

COLM: I… know you

BARBARA: Do you?

COLM: Yes. I do.

BARBARA: Where? Where do you know me from?

COLM: I… can't say. They're listening.

BARBARA: Who?

COLM: The gods we made in our dreams. We dreamt such terrible gods and they throw down their agony into our lives for no other reason than to keep themselves amused. Have you noticed the agony of life Barbara?

Looks into her eyes.

Oh Christ. You have. You have, haven't you. So much.

GAVIN steps forward.

GAVIN: Do you recognise me?

BARBARA: Help him. He needs help.

GAVIN: Do you recognise me!

Pause. COLM looks up at GAVIN. Reaches for him, but is suddenly distracted by his own hand, staring in wonder as if he had never seen one before. Beat. GAVIN starts to pull out his gun, load it.

BARBARA: What are you doing? What's he doing?

GAVIN: *(To CASTILE.)* Are you insane? This? We can't follow this.

CASTILE: He's a little… he's, he's not himself but if we –

GAVIN: Not himself? Did you say not himself?

CASTILE: Look, I have made contact on the other side, his son, if you can –

BARBARA: You said he was going to help him!

GAVIN: There is no help for him. This is the best help for him.

CASTILE: Jesus Christ, don't do this, not this, Gavin, please…

GAVIN: He is fucking mad! He is insane, Richard wants him dead, and I must be mad to even be talking to you, and you? you're serving a madman!

Suddenly COLM gets up. Stares at GAVIN. GAVIN steps back.

COLM: How did it get to this? How did we all become servants of insanity?

GAVIN stares at him. Looks at the others. They say nothing. Looks back at COLM, but COLM just stands there. Staring at him.

Without warning GAVIN goes. Pause. CASTILE starts to follow.

BARBARA: What are you doing?

CASTILE: I have to stop him. I have to… we need him.

CASTILE follows GAVIN. BARBARA goes to follow him when a shell lands nearby. She cowers down, but COLM responds to it standing. Suddenly runs in the other direction, into the battle.

BARBARA: Not that way, that's fucking… Bob!

She goes after him.

* * *

MARTIN runs on, out of breath, terrified, looking for somewhere to hide. Nowhere. Panics.

A Big Soldier enters, a large terrifying man, grinning, pointing his gun at MARTIN, who backs away. MARTIN sees his uniform.

MARTIN: No, no, look, I'm one of you, I'm…

(Trying to show him his uniform.) I'm one you, look, the uniform, look, I was just with him, because, because… I'm one of you.

The bigger man raises the gun, points it at MARTIN. Pulls the trigger. Nothing. Just a click, no bullet. Pulls again. Same. Again. Same. Beat. MARTIN suddenly picks up a piece of wood, brandishes it, trying to look threatening. The Big Soldier pauses, then smiles. He turns his gun round and advances on MARTIN, using it as a club.

MARTIN doesn't know what to do, there is nowhere to run, so out of panic, swings the wood wildly, catching the Big Soldier on the tooth with a lucky blow, who steps back, shocked.

Pause. The Big Soldier touches his tooth, which is now chipped. Stares at MARTIN.

Sorry. Sorry, I'm, no, look I'm sorry, I'm really, really –

The Big Soldier charges, enraged. MARTIN somehow manages to parry the first few blows, but it is clear that he cannot win.

Suddenly the OLD SOLDIER steams on and barrels into the big man, knocking him to the ground, going with him, rolling together. The OLD SOLDIER uses the momentum to get on top of the Big Soldier and head butts him immediately before he has a chance to recover, keeps doing it, again and again and again, until the man is definitely unconscious.

Pause. The OLD SOLDIER breathes heavily. Looks around. Finds a rock. Smashes the Big Soldier's head with it until he's sure that he's dead. Gets off him. Looks at the rifle. Throws it away.

OLD SOLDIER: Useless.

Notices that MARTIN hasn't moved. He is staring at the corpse.

Told you not to fucking stray. Come on.

He goes. MARTIN is still rooted to the spot, wants to speak, seems to want to tell someone about what has just happened, but there is no-one there apart from the dead man. He runs off after his friend.

* * *

Massive shelling. Smoke.

COLM runs on. He is shouting at the bombs, but the shelling is too loud for a word to be heard. Shells go off around him, earth and smoke filling the air. He shouts, the shells, the craters and the sky.

BARBARA enters, head down, trying to keep out of harm's way. She is calling his name but he doesn't notice her.

BARBARA: Bob! Bob!

But he cannot hear.

COLM: Do you want me to live? Is there such a thing as mercy? Then give me a sign! Give me a sign!

She runs forward to him, desperate, ducking down.

Suddenly the shelling stops.

At exactly the same time that COLM sees her. She sees him. Silence. He looks around, sees that it is calm. She does too.

Pause. COLM looks down at the bag. Opens it. Takes out the cat. It is alive. Stares at BARBARA. Goes to say something but instead suddenly walks away. She moves as if to call, but...

COLM: Ow!

He comes back, without the cat.

He scratched me.

BARBARA: The shelling's stopped. Bob?

COLM: That's not my name. I have another name. A darker name, a name of brutality, stupid, pointless brutality, but my name, I revelled in my name, loved it, why? Why did I love such a name?

BARBARA: The cat. Did you see the cat –

COLM: Colm, yes, yes, yes, yes, Colm. That was it. That was my name.

Pause.

BARBARA: What?

COLM: Colm. My name was Colm.

Beat.

So quiet. It's suddenly so... fucking quiet.

BARBARA: Your... your name is...

He looks up at her.

COLM: You have his eyes. Who? His. Who's? Who's eyes? His eyes, you have his eyes. I knew a man once, Ken, you have his eyes, you have Ken's eyes.

She is stunned, can't hardly speak, can hardly stand.

I used to believe that the universe was cruel, that gods made things this way so that cruelty was the only way of existence. But now I see the truth. That they watch us and what we make and what we do with our lives to each other and they weep. They watch us and weep.

BARBARA: You're him?

Pause.

COLM: Have you seen a cat? I've lost my cat.

Suddenly he gets up, looks around.

Where is that cat?

Goes after the cat.

BARBARA has not been able to move. Stands there like she's made of straw and might collapse. Suddenly she's gripped with a fury. Looks around. Moves. Stops. Fury. Looks around, sees something sharp on the ground, a broken knife. Picks it up, heads after COLM , consumed by blood. But the OLD SOLDIER enters. They both stop. Stare. Pause. She runs off the other way. He stares after her. Wondering.

MARTIN enters trying to keep up. OLD SOLDIER sees him.

OLD SOLDIER: The ridge has collapsed. Richard's men have over-run the centre, they're everywhere. All gone, all lost. We have to go.

MARTIN: What? We lost the ridge, then?

OLD SOLDIER: We've lost everything.

MARTIN: And Catherine?

OLD SOLDIER: Forget Catherine, boy, she's lost they're all lost. Time to get out. You and me. Head somewhere, stay

low, survive quiet, off the land. Years if need be, wait this
out. Live.

MARTIN: Jesus Christ. That's what I've been fucking saying!
Thank god.

OLD SOLDIER: *(Gives him a knife.)* Take this. Stay close.
They're all around.

MARTIN: Right. I'm really not very good with –

OLD SOLDIER: Follow me. Stay close.

*Begins to go, MARTIN following. Stops. Puts his hands in the air,
moves back. MARTIN looks, almost lets out a cry. RICHARD's troops
enter, guns raised. Beat. MARTIN panics, thinks, looks at his uniform.
Grabs OLD SOLDIER from behind and puts the knife to his throat.*

MARTIN: I'm… I'm with you, look, look at the uniform, I'm
with you, I'm with, got this one. This one's… filthy –

OLD SOLDIER: Boy, don't –

He slits the OLD SOLDIER's throat. The OLD SOLDIER collapses.

MARTIN: See? See? Filthy dog!

*Spits on him. The OLD SOLDIER dies. The troops come over to him,
guns still raised. They look at his uniform.*

OFFICER: Come with us. Catherine's surrounded. Last stand.
We need men like you.

*They go. MARTIN, looks at the OLD SOLDIER. Might say something.
Doesn't. Heads off after them. Back into the madness.*

* * *

CATHERINE waits, anxious.

IAN bursts in with two bloodied officers.

IAN: It's gone, it's over, we've lost the ridge.

We've lost the ridge, they're coming down the ridge. The east is gone the west is collapsing, they've taken the ridge and they're coming to –

CATHERINE: Where's Jimmy?

Beat.

They told me he'd gone. But I don't think that's true because if that was true I might've heard my heart crack. And I don't think I have. I don't think I've heard it crack, Ian. Have you heard it crack?

Ian?

Pause. IAN goes to her.

IAN: Catherine he's gone.

She stares at him. Suddenly she pulls IAN's gun out of his holster. Points it at him, tries to fire, he cowers, but she cannot fire. Points it at an officer, tries to fire, he cowers, but she cannot fire. Puts it to her head, tries to fire, can't, puts it to her heart, tries to fire, but she cannot fire. She drops the gun. IAN goes to her, but she pushes him back, turns away, from them. They wait.

CATHERINE: …I told you not to love him.

She turns back, completely composed.

CATHERINE: Okay.

Okay. Good. There. That's fine.

IAN: Catherine we should run

CATHERINE: Yes, that's all… that's fine then, that's fine.

IAN: we should flee, we should –

CATHERINE: No.

Where to? There is nowhere. No, I am not… I am…

I am not…

Beat.

We shall wait. Put your arms down, everyone, put your weapons down. *(To an officer.)* Tell them to put their weapons down.

IAN: But –

CATHERINE: *(To the officer.)* You, go out there, tell them to put their weapons down.

He doesn't move.

Now!

He goes.

IAN: Catherine, Richard's going to be here any minute.

CATHERINE: Yes, and I am going to greet him like joint CEO.

IAN: What?

CATHERINE: Yes. We've had our differences, but now… I am going to convene a, a board meeting.

IAN: What?

CATHERINE: Yes. A board meeting, I think there will be enough of us, I am going to convene a board meeting, whereupon I shall immediately put forward the motion that Richard take full control of Argeloin.

We shall take up our previous offices. Everything will be fine.

IAN stares at her.

I have the board room table here. It is within.

IAN: Catherine…

CATHERINE: Trust me.

She sits to wait, indicating that the officer and IAN should do the same. The Officer sits, slowly. IAN sags.

IAN: I always have.

He sits. Waits. Silence. Noise outside. Shots fired close, the officer moves.

CATHERINE: Wait!

He does. The doors are kicked open. Troops enter, guns raised, followed by RICHARD and GAVIN, all a bloody mess. Pause. CATHERINE stands, regal.

Richard. I welcome you.

She holds out her arms to him. He stares at her, doesn't move. She still holds her arms out, but he doesn't move a muscle. Slowly she lowers them.

We... have had our differences, yes, but now I think it is time to put all this aside. I propose a board meeting.

Silence.

RICHARD: A... board meeting?

CATHERINE: Yes. Yes, Richard.

I have had the boardroom table brought here, inside. We can sit down. We can settle this. The boardroom table is here. It is within.

RICHARD: Within?

CATHERINE: Yes.

RICHARD: In there?

CATHERINE: Yes.

You're thinking that this has gone too far, that maybe we are beyond –

He goes straight to her, grabs her by the hair and drags her into the other room, kicking the door shut, behind him..

Silence. GAVIN indicates something to his troops and they take the officer out, leaving him alone with IAN. Stares at him. Looks down.

GAVIN: God help us all now.

IAN is about to reply when more troops burst in, bloodied, wild. BETH follows. She looks around. GAVIN goes to speak.

BETH: Where is he?

GAVIN: We thought you were dead, Jesus Christ, we thought you –

BETH: Jimmy. Where?

GAVIN: What?

She heads straight to IAN, pulls out a blade. GAVIN goes to stop her, but her troops point their weapons at him. He freezes. BETH watches him.

BETH: I have in this day been reborn with them we are in some such way and you are as nothing, we know what a life is lived in there bodies and we know what precious fragile of death awaits all who so there is dark, dark, a new, a new me, actually, but one thing, one thing remains.

She turns to IAN.

Where. Is. Jimmy.

IAN: I… I don't know.

She grabs him.

Why are you asking me? I don't understand why you are asking me, you know where he is, he's with you, he's always been with you.

Beat.

BETH: What?

IAN: He's your man, he's Richard's man.

BETH: Ri…

IAN: Yes, of course he's always been Richard's, from the beginning, from the very beginning.

BETH: What?

IAN: Ask Richard where he is.

BETH: What?

What?

Pause.

What, then?

She goes to speak again, but can't. Something hits her inside, but immediately passes. IAN watches. GAVIN watches.

RICHARD comes out of the room. CATHERINE does not. Sees BETH.

RICHARD: You're alive.

She lets go of IAN, points her gun at RICHARD's head.

Pause. He stares at her. At IAN. Back at her. Opens his arms.

And?

You cannot hurt me. I am beyond you now.

I am a god.

She shoots. He collapses. She goes to his body, looks. Sees he is dead. Turns to her men.

BETH: A tyrant death, gone, over, gone. Now is a new, now is our, now is a new time, our time. We shall remake the world in our image.

GAVIN: Beth?

BETH: Execute all prisoners. Distribute food to the people. Assess the people. Assess the people by value.

GAVIN: Beth?

BETH: Assess the people by usefulness and value. Cull the
 bottom twenty five percent.

GAVIN: Beth?

BETH: A new day is here. My day.

*She leaves, followed by all except GAVIN, who stands there, alone.
He looks at the door that RICHARD came out of. It is still open. He
takes a step towards it. Stops, as if afraid of what's inside. Goes to
it. Stops. Goes in.*

*　　*　　*

CASTILE enters with JIMMY and troops. They search the debris.

JIMMY: Are you sure it was here?

CASTILE: Yes. They were here. This was her house. I thought
 they might come back, I thought...

 We'd better go.

JIMMY: They might be alive. They might have survived,
 they –

CASTILE: We have to go. This whole place is crawling with...

 We have to go.

*Beat. JIMMY nods. CASTILE and the troops start to go. JIMMY lingers
a moment, then leaves with them.*

Third Act

A hillside, remote, secluded, bushes at the back a tree poking through, all under an overhang. Quiet.

COLM runs on, terrified, his eyes wild. He looks around for somewhere to hide. Sees the tree, runs over, grabs at the trunk trying to shinny up it, but his arm is still damaged.

BARBARA enters, a huge, heavy stick in her hands, a weapon. Sees COLM. He sees her, stops. They stare at each other, panting.

Suddenly she runs at him. He scrambles to put the tree between them before she reaches him, just managing to do it as the branch cracks down on the trunk snapping in two. BARBARA picks up the broken wood, a piece in each hand glares, at him. Beat.

He goes to speak but she suddenly goes for him, causing him to leap to the opposite side to dodge the blow. She goes for that side, but again he moves, keeping the tree between them. They circle the tree. Without warning she feigns one way, causing him to move back, and throws herself the other, coming so close to COLM that he has no choice but to bodily throw himself into the bushes, disappearing completely.

She stands, staring at the bushes. They are still. She begins to wade in but is immediately scratched back by the brambles. Frustrated and furious she throws one half of the stick into the bushes where COLM disappeared. Nothing happens. Thinks. Puts down her stick and gathers rocks from the ground. Returns to the bushes. Starting at one end she throws a rock in as hard as she can. Nothing. She moves along a little and pegs another in. Nothing. Moves alone, throws another. Nothing. Moves along, throws another. Nothing. Continues.

Moves, near the end now, pulls her arm back to throw the rock, when suddenly COLM scrambles out of the bushes on his hands and knees. She runs, gets her stick, explodes into rage, swinging it at him like a club. He stumbles, lands on the floor. She advances. He turns round to face her, just as she stands over him. She raises the stick above her head. He raises himself onto his elbows, but petrified, seems to make no attempt to shield himself from the blow.

She hovers there for a second, shifting her weight to get the maximum force into the stick. He doesn't move. All he can do is stare up at her. She brings the stick down as hard as she can, but instead of hitting him she lets go of it and hurls it off into the distance.

Silence.

She walks away from him towards the tree, leans on it, panting. He lies back on the ground exhausted. She is crying, silent tears. Covers. He does nothing, looks up at the sky.

COLM: I think it's going to rain.

> *They stay like that for a long time. She gains control of herself.*

We could do with it. We could do with the rain.

The clouds are so close. I could touch them.

> *Reaches out his hand. Cannot touch the clouds. Pulls back disappointed. Sits up.*

BARBARA: Why were you following me?

COLM: I... didn't know where else to go. I've been following you these past few days. I didn't know where else to go. And then I ran out of food –

BARBARA: You'd better go. I mean it. I swear, you'd really better fucking go.

COLM: Yes, yes, of course, I'll go.

> *Beat. Doesn't move.*

There's sheep. On the mountainside. Alone. They're alone. No-one looking after them. Did you see?

> *Beat.*

I'd like to apologise.

> *She stares at him.*

I can't remember anything before this. I can remember, I think I can remember if I want to, but if I'm quite honest

I think I might be slightly terrified to remember. I think I feel that loosening those memories will be like opening a cupboard and everything will fall out on me and crush me. So I hope you won't mind if I don't open that cupboard because I don't want to be crushed by who I've been and what I've... done.

But I think I'm better now.

BARBARA: Do you know what I look at when I see you? I see a waste of flesh. I see a waste of molecules. I see something that looks like a human being but walks around being so far less than human that it's impossible even to feel pity for you. These past few days? All I could think of these past few days was what it would feel like to stick a knife in you.

COLM: I'm... sorry.

Beat. She pulls out a knife. He watches, suddenly scared.

What are you going to do with that knife?

BARBARA: I'm gonna kill you.

COLM: Are you?

BARBARA: Yes.

COLM: Don't.

BARBARA: I am. I'm gonna fucking... scalp you. I'm going to cut your scalp off.

COLM: Don't. Please don't cut my scalp off.

BARBARA: You're nothing to me. You're filth. There's no-one here, miles from anywhere, I'm going to kill you, I'm going to kill you with this knife.

Goes to him grabs his hair, pulls his head back.

COLM: Don't, please don't kill me with that knife.

She puts the blade of the knife to his hairline.

132

Please, don't…

She is straining to make the cut.

BARBARA: I'm gonna do it, I'm gonna fucking…

Strains. Strains. Nothing. Beat.

Alright, I'll cut your finger off. Give me your hand.

COLM: No, please. Please don't cut my finger off, please…

He tries to withhold his hand.

BARBARA: give… me…

*She pulls it out. Puts the knife to his little finger. Strains to do it.
Strains. Strains.*

*Suddenly she lets him go and walks away. Pause. He gathers himself.
She turns on him.*

What use are you? Tell me one thing that you are useful
for.

Silence.

COLM: I'm hungry. Are you –?

BARBARA: No. Because I've got food. I found food, my food,
it's my food.

COLM: I could hold things.

Beat.

BARBARA: What?

COLM: I could… hold things.

BARBARA: What things?

COLM: Yes, I could, I could hold things, if you were doing
something, if you need someone to hold something while
you fixed the other end or

BARBARA: I don't need anyone to hold things.

COLM: You might.

BARBARA: I don't

COLM: Or I could forage.

BARBARA: What for?

COLM: I could find things.

BARBARA: What things?

COLM: Rocks.

BARBARA: What the fuck would I need rocks for?

COLM: Or sticks, I could find.

BARBARA: I've got sticks, these sticks, all the sticks in these bushes and on this tree they're all mine.

COLM: I'm good with contract law.

Beat.

No, that's not very, sorry, that's a stupid.

Mathematics. I've always you know had a razor sharp, in that department, you see I'm of a generation that had to multiply and I've always thought that I had a very good sense of balance. I've always been secretly quite proud of my sense of balance.

You're going to build a shelter, aren't you. Here, under this tree.

Beat.

I could hold things. One always need someone to hold things.

BARBARA: Yes, I'm going to build a shelter. I do not need a grasp of contract law.

I do not need mathematics. I do not need your sense of balance and I do not need you to hold things.

I do not need you, I do not want you. Leave me alone.

Pause.

COLM: I'm sorry about before, really, I really am –

BARBARA: Before when?

COLM: Before... now, following, these past few days, I shouldn't've –

BARBARA: Not the last twenty years, then? Not about killing my family?

He suddenly doubles up, as if the memory had caused him physical pain. She watches.

Does that hurt? Does memory hurt? You are less than nothing to me.

Goes off in the direction from which they came. After a moment she returns with a backpack, ignores him. She begins to take stuff out. Looks up at him. Tries to ignore him. Can't.

What? Are you crying? Is that what you're doing, you're crying?

Little cry baby, crying?

Pause.

I cried. I cried a lot, but I was a child when I cried, not some desiccated old cunt. I was a child.

I could kill you now. Killing you would be like squeezing a spot.

She stares at him, but he is lost in his agony.

Stop crying.

Stop fucking crying!

She goes back to unpacking her stuff. He recovers. Watches her. Watches her in wonder.

COLM: You are the greatest thing I have done.

She looks up at him. Pause. He is on his knees. Holds his arms out wide.

I am so sorry, daughter.

Beat. She storms over to him, grabs his hair again, puts the blade to his hairline. He pulls back this time, sensing that this is different, but she has a good grip. Begins to cut. Blood starts to run down COLM's forehead.

Suddenly she lets go and he collapses. She goes back to her stuff. He touches his head, then looks at the blood on his hands.

Oh my god. I deserve so much more.

BARBARA: You'd better go.

COLM: Yes, yes, of course. I can't.

BARBARA: I'm building a camp, you'd just better go, you'd just better stay away.

COLM: Yes, yes, of course. I can't, though. I can't.

BARBARA: You'd better. You'd just really, really better.

* * *

BARBARA is working at the back, under the tree, alone. In front of her there is now what seems to be a make-shift shelter, branches, corrugated plastic, bits of wood and old door, along with the bushes at the back, now raised. The entire construction is about 15 foot wide and goes back about 10 foot, and has created a three foot tented crawl-space inside. From a key point in the centre a rope runs up to a strong looking branch in the tree above and then down to a tangle of bushes to the right, but the rope is slack and supports no weight.

COLM enters, his head now bandaged. He is dragging behind him a collection of branches loosely held together to form a kind of mat, seven or eight feet across, but the whole thing looks ridiculous, a mess, as if a storm had somehow blown a collection of sticks and leaves together so

that they happened to lock into this shape. He stops. Puts it down. Looks at what she has made. Looks at what he has made.

COLM: I made this.

She looks at him. Beat. Goes back to her work. He doesn't know what to do.

It's a shelter.

I thought shelter but then it became more of a, well, mat, I think or, yes a mat and I thought, pursue the mat idea, proceed with, because if one had a waterproof, then that would be…

Pause. She goes back to her work.

I just picked these things up. I just picked them up and I fashioned them. I fashioned them into something useful. It was wonderful.

Beat. She has finished putting the branch in. She checks that the rope is secure. She goes to the other end of the rope.

Of course next to yours it's perhaps not quite so incredible, as my feelings first led me to believe.

Would you like to have this?

She stares at him, holding the rope.

I mean, the front of yours is open and there's not much space to –

And that's not a criticism, good lord no. But the truth is, Barbara, that when it rains, from a certain angle, I think the rain might, to some extent, come in.

Beat. She leans back and pulls hard on the rope, causing it to go taught and to begin to pull the centre of the shelter up. She heaves on it, hand over hand, lifting the roof of the shelter higher and higher, the walls coming up after as they were obviously designed to do. COLM watches as the space inside the shelter grows until it is tall enough to stand in. The entire thing looks waterproof and windproof and there

is already a nest of pine leaves put together inside, creating a bed. She ties the rope around the root of one of the bushes. Steps back to look at it. COLM is staring at it, mouth open. It is very impressive. He looks at her. At the shelter. At the rope. He looks at his mat. It looks like a bush that someone has dropped a shed on. He lets go of it without thinking.

BARBARA wipes her hands and goes inside.

I'm hungry.

BARBARA: There's plenty of food up here. If you want food, catch some food.

COLM: Have you caught anything?

BARBARA: I

I haven't got the traps right. The design, it needs…

Beat.

COLM: You're very good at all this. I mean that's just… amazing.

How did you know what to do?

BARBARA: I… I don't know, I

I just looked at what needed to be done and then I did it.

COLM: Can I look at it?

BARBARA: What?

COLM: Can I?

BARBARA: Get the fuck away from me.

COLM: Oh, no, no, I just thought that –

BARBARA: Step back, or I will… Step back there.

COLM: But –

BARBARA: Back!

He takes a step back.

More.

Another.

More.

Another. Pause.

Why should I care about anyone other than me, just give me one reason, one good reason.

COLM: One?

Thinks.

I can't.

I'm hungry.

BARBARA: Don't keep saying you're fucking hungry, I'm not here to feed you.

COLM: No, of course. I didn't mean that, that just came out, it was, it was

She goes back into her shelter.

I was up there on my own, making my mat and I just said it up there as well, I just said 'I'm hungry' just like that, 'I'm hungry' to no-one in particular, it just came out, I was completely alone.

You're right, there is a lot of food around. Getting hold of it seems to be quite tricky. It moves quite fast.

I fashioned a spear.

She looks at him.

Yes, I fashioned a, a spear, it was very difficult because I didn't have a knife, but I used a stone that I found that looked quite sharp, it wasn't sharp, not what we would call sharp, but I hacked at this piece of wood with this supposedly sharp stone until I had something that

resembled a point. But in truth it looked like I'd chewed it into a point.

I threw it at a squirrel. Then I threw the stone at it.

BARBARA: Okay.

COLM: Pardon.

BARBARA: You can look at it.

Just don't touch anything.

Beat. He goes to the shelter. Begins to look at it, the roof, the walls, at how the branches interlock and at the leaves and pine branches that have been woven in for waterproofing.

COLM: Amazing. It's amazing.

BARBARA: It's not amazing.

COLM: And it's all supported on this rope?

BARBARA: Not all, but mostly –

COLM: Absolutely amazing. *(Beat.)* And you think that's strong enough?

BARBARA: What?

COLM: The bush where it's rooted. You think that's strong enough, do you.

BARBARA: Yeah, why?

COLM: You don't think it'll come out?

BARBARA: No, why would it –

COLM: Come loose? I mean in the rain, when the soil gets wet might it –

BARBARA: Right, out.

She ushers him out. She goes back in, starts work on the walls. He looks at his mat. Thinks.

COLM: What if I dig a hole? I mean I was looking at my mat and I thought if I dug a hole and put it on top, wouldn't that create some shelter?

BARBARA: A hole? In the mud? A hole in the mud with some sticks over it?

COLM: Well, it would be something...

BARBARA: And you'd be sitting in it, would you?

COLM: I could line it with leaves. It would be like a nest, or a set, or

BARBARA: A set?

COLM: I think it could be quite – yes, a set, don't badgers live in sets? – yes, I think it could be quite snug. I could dig it here in the mud and –

She glares at him. He moves ten feet further away.

I mean here. And when you think about it why should shelter always be above the earth? I could line it with leaves.

BARBARA: It wouldn't work. For two reasons.

Water. It would fill with water when it rains. It would be a big puddle. You'd be living in a big puddle.

COLM: And what's the other reason?

BARBARA: The other reason is that if you dig a hole there or anywhere near there I'll come over in the middle of the night with a big fucking rock and smash your brains in.

Beat. She goes back to her work. He looks up at the sky. Sits. Continues to stare upwards as she works on.

COLM: I can't help feeling that being here is beautiful. I'm hungry.

Beat. She goes deep into the shelter. She comes back out with a spear in her hand and immediately marches over to him. For a second he

thinks she is going to stab him with it. For a second she seems to be considering this. But she thrusts it into the ground in front of him and walks back. He stares at it. At her. Pulls it out of the earth.

Thank you.

BARBARA: I've got plenty more.

COLM: Have you caught anything with them?

She says nothing, gets on with her work. He looks at his new spear.

It's a shame, isn't it. With all those sheep sitting out there.

BARBARA: Stay away from the sheep.

COLM: No, no I was just

BARBARA: Those fields are exposed they can be seen for miles, if anyone was watching, stay out of those fields. Stay the fuck away from those sheep or I will stick that spear in your eye.

COLM: Do you think there is anyone? To be watching, I mean?

She doesn't answer.

I'm hungry.

Beat. For a minute she seems to be considering hitting him. Instead she heads back into the shelter, to her pack. She comes back with a tin. Pulls back the lid. He tries not to look desperate. Pause.

I've thought of a reason. Why you should care. You said give me one reason why I should care about anyone other than myself, yourself and I've thought of one. I've thought of a reason.

For you, Barbara. Your kindness. So there'll be something of you left.

She stares at him, suddenly furious, but unable to move. She spits in the tin. Hands it to him. He takes it from her and looks inside. He

can't help but feel slightly disgusted. She goes back into her shelter. He continues looking into the tin.

Is this…? It's custard.

BARBARA: Yes.

COLM: Right.

What should I… I mean, what should I… did you have something in mind that I should… I mean how should I eat it?

BARBARA: Well, what you should do is take your new spear, pop out there and hunt yourself down a nice treacle sponge.

She continues working. He looks back into his custard. Suddenly he drinks it all off in one go, greedy, desperate. Gone.

COLM: Thank you.

He sits with his tin and begins to use his finger to work the last bits out. If he could get his face in there to lick it, he would. She continues to work. The tin is clean. Pause. Suddenly he gets up and goes over to her. She stops, stares at him. He seems to be struggling with something.

I… I'd like to offer you a job, Barbara.

Beat.

BARBARA: What?

COLM: I could use someone like you, strong, bold, I mean you have so many qualities, my organisation could

BARBARA: A job?

COLM: Yes. When things are better, I mean, yes.

BARBARA: You're offering me a job?

COLM: You don't have a business background, but that is not the hurdle it once was. These days we understand that

experience, knowledge, these things can be acquired, and are as nothing next to –

What you have, Barbara, is backbone, spirit, drive. Courage. Strength. Power. What you have, these things, these things are…

Beat. She is still staring at him.

I have seen in you such ability, such strength and I cannot pass that by.

Pause. Suddenly she laughs, genuinely amused. He smiles. Her laughter subsides.

BARBARA: Colm, I was wrong. The big hole idea is great. Go and dig a big fucking hole, sit in it, cover yourself up and wait for the rain. Please.

* * *

It is raining, pouring down.

COLM sits on the ground (though not in a hole) trying to use his mat for cover. It is less than useless. BARBARA sits in her shelter, bone dry. She has a blanket around her keeping her warm and she should be happy, but she cannot drive COLM out of her mind.

He realises the ground under him has become wet. He shuffles a little to his left, crouches back down. But this area is wet and very cold. Faffs for a minute, trying to stand or sit in a position where he isn't in cold/wet, but it is not possible. Looks at the place where he was just sitting. Shuffles back there, sits. But it is now wet and cold.

BARBARA watches, fuming, his every move making her stand or sit in frustration at his stupidity. He stands there looking around him for somewhere dry to sit, his mat held above his head. There is nowhere, so he crouches, awkwardly, holding the mat on his shoulders. BARBARA cannot believe it. The idiocy of this position seems almost a personal affront to her. She throws the blanket off and sits facing away from him. But a moment later she is pacing, looking at him, absentmindedly covering herself with the blanket she discarded only a moment ago.

She stops, stares at him. Thinks. Goes to say something. Doesn't. Throws the blanket down again, furious. He's just fucking crouching there. Beat. He moves one pace to the right. She can take no more. She leaves her shelter and heads straight for him. She has taken no more that a couple of paces when the bush that she tied the rope to is suddenly yanked out of the now wet ground into the air, roots and all, causing the shelter to collapse down in on itself.

She runs to it, trying to lift it up, COLM turning to notice. She pushes and pushes, but the now wet shelter seems too heavy. She goes to the end of the rope, unties the bush, lets it fall, then tries to heave the shelter up, but it seems to have fallen into a position where it is locked together. She goes to the front of the shelter again, tries to loosen it with brute force, but it is no good.

COLM is standing nearby, watching, the mat over his head.

She takes the rope back as far right as it will go to get maximum pull, heaves, but it hardly seems to move. COLM watches. Beat. He watches, she heaves.

Suddenly he runs to the centre of the shelter and pushes it with all his strength. She pulls, he pushes. More. More. The shelter shifts free from its locked position and begins to go up. More. More. One final huge effort and it is back to where it was. COLM supports the weight while she looks for somewhere to tie the rope off. She brings it round to the tree, checks to see that COLM has the weight then ties it to the lowest branch, wrapping it around several times for support.

She runs back into the shelter with COLM, taking the weight now with him. Tentatively they let go. It holds. She pushes and prods at it, pulling it to see how firm it is, but it seems fine. They stand there, breathing heavily, soaked. Beat. They are both in the shelter. They look at each other. COLM looks at his mat, then back at her. Beat. Slowly he sits, not taking his eyes off her. Beat. She sits as well, looking out into the rain. When he is sure that she is not going to do anything he too looks out, into the rain. They sit there, watching it rain.

* * *

Morning. BARBARA is out front of the shelter, experimenting with a new trap. There is a large flat part with sharp wooden spikes attached, weighted with rocks, propped up with a thick twig at an angle. Underneath, a platform with a morsel of food. She moves back. Picks up a nearby stick. Slowly she pushes it into the trap. Immediately the twig gives and spikes fall heavily on the stick. She stands. Looks down at the trap, confused, no idea at all what the problem is.

COLM comes on in triumph. He has his spear in his hands, on the end of the spear a dead squirrel. The look at each other, COLM beaming. Pause.

COLM: Squirrel!

BARBARA: Is that your squirrel?

COLM: Yes. I got it, yes, I got a squirrel.

BARBARA: Really?

COLM: Yes, look, we can eat it, we can eat squirrel! It's mine, it's… It's ours.

BARBARA: How did you get it?

COLM: I speared it.

BARBARA: You speared it?

COLM: Yes, Look. It's on my spear. I speared it.

 Food at last, at last we can, Barbara, something other than, because the tins are running out, no, I know, I've seen, and you've worked so hard, so very hard and your traps are so elegant and perfect it makes absolutely no sense to me at all that they haven't caught anything, but we do need to get something, don't we. It's a beautiful squirrel.

 Beat.

BARBARA: How do we eat it?

COLM: We cook it.

BARBARA: We can't have a fire, I keep saying, the smoke, the smoke will

COLM: We cook it at night.

Beat.

BARBARA: At night?

COLM: No-one can see smoke at night.

Soup.

BARBARA: Soup?

COLM: Or stew. It'll make it go further. We could make a soup/stew, I could get some water, we could fill the old cans with water and meat.

BARBARA: Meat

COLM: Squirrel meat and maybe there are some potatoes left and there are nettles up there, tons and tons of nettles it would be amazing, soup, stew, I think we should get two meals each out of this one squirrel.

BARBARA: I've got some salt.

COLM: You've got some salt!

BARBARA: Maybe there are some wild herbs

COLM: Oh my god: herbs!

BARBARA: It's small, isn't it.

COLM: Well it's a squirrel

BARBARA: Are they all that small?

COLM: Yes, they're squirrels I mean squirrels are small, but

BARBARA: But it's something.

COLM: It is. I mean if it was a rabbit, now a rabbit would be – I told you, I said it was worth it, the spear, your spear, I mean look.

BARBARA: You think cans?

COLM: Yes.

BARBARA: We could place them in the embers, they could cook in there.

COLM: Yes! Yes.

Beat. She almost smiles at him. Goes over to the squirrel.

I feel alive. Can I say that? I know it seems wrong, but I was up there, just waiting and hunting and whatever, but I just felt so… alive.

She pokes the squirrel. Looks up at him.

BARBARA: Did you kill this squirrel?

Pause.

COLM: It's a squirrel, yes.

BARBARA: Did you kill it?

COLM: It's dead, it's not…

BARBARA: Did you catch this?

COLM: I got it, yes, and

BARBARA: You got it or caught it?

COLM: caught it, I caught it, yes.

BARBARA: You caught this squirrel?

COLM: Yes, I got it, up there, I

BARBARA: Got it or caught it?

COLM: I got, caught, I got, it's dead. It's on my spear, I speared it.

BARBARA: Was it alive when you speared it?

No answer.

Colm?

COLM: Yes?

BARBARA: Was the squirrel alive when you speared it?

Beat.

It's cold.

COLM: Yes, well it's dead, it's…

She is staring at him. He cannot keep eye contact.

BARBARA: You fucking idiot. You found this, didn't you?

COLM: I speared it, I put my spear into

BARBARA: Was it alive when you speared it?

No answer.

Was it alive when you speared it? Was it alive when you –

This is shit. You can't eat this.

COLM: No, no, look it's meat, it's good meat.

BARBARA: You found it, didn't you. You fucking… you found
a dead squirrel lying on the ground, you stuck your spear
into it and you brought back home like a puppy with a rat,
didn't you. This isn't meat, okay? This is poison. This is
death. This is lying around in your own shit for a couple of
days?

COLM: It looks good.

BARBARA: What?

COLM: It looks… like a good…

*Beat. Suddenly she snatches the spear from him. For a minute she
looks like she might stick in his flesh, but instead she flings the squirrel
into the bushes. He instinctively takes a step after it, but stops. She
throws the spear down and goes back to her traps.*

We need to eat.

BARBARA: Not dead things, you fucking… How stupid can one person be?

COLM: I wanted to bring you meat, I wanted us to have meat.

BARBARA: Stupid old bastard. You can't just find things and eat them.

COLM: Isn't that what foraging is?

BARBARA: No, it is not what foraging is.

COLM: Hunter gatherer, isn't that –

BARBARA: You could've killed us!

COLM: I felt so alive…

BARBARA: *(Mimicking.)* 'I felt so alive, I felt so alive' fuck your alive, with your dead squirrel stew.

Beat. She goes back to her trap. He watches.

COLM: The irony is we're surrounded by food. Nutrients in the soil.

All of that energy. Beaming out of the sun. If only we could use it.

BARBARA: Why don't you grow some leaves, then?

COLM stretches out his hand. Seems to be considering growing some leaves. Stops. Watches her. She is fiddling with the trap.

COLM: Sorry. I'm sorry Barbara.

Beat. She carries on. He comes over to her. Looks down.

They're not working are they. Your traps.

She doesn't answer.

I don't understand. I mean you've done such a great job.

BARBARA: Not that great if they know it's a trap.

COLM: Do you think they know?

BARBARA: How could they know, they're animals.

COLM: I mean some instinct.

BARBARA: I don't know. There's too much stuff, all this stuff scares them away, yes some instinct, definitely some instinct.

COLM: Because the mechanism is... Is it too light?

BARBARA: No, look.

She demonstrates. Again it works.

COLM: Perfect. It's perfect, it makes no sense. I mean people do trap.

BARBARA: Oh yeah, they do. People trap, trappers trap, but it's the knowledge.

COLM: Trappers have some knowledge that we don't?

BARBARA: You have to know, you need the knowledge.

COLM: We could dig a pit. Cover it with leaves.

BARBARA: I tried that. They just go round.

COLM: This trap is beautiful. It should work.

She notices something.

BARBARA: Have you changed your dressing?

He stares at her

Colm, have you changed your dressing?

COLM: I think so.

BARBARA: You have or you haven't?

COLM: I... think I did.

BARBARA: Today?

COLM: Today?

Yes. Yes, I'm sure I did.

BARBARA: You fucking haven't have you?

COLM: Today, you mean?

BARBARA: Jesus Christ. You have to clean it every day…

COLM: Right, right. Sorry, of course

BARBARA: Because otherwise out here, if you get infected

COLM: I won't do that, I won't get infected

BARBARA: If you get infected out here you can die.

COLM: Sorry.

BARBARA: Sit down.

He does as he's told. She goes in, returns with some water and a bag. Slowly undoes his dressing, the wound is angry and red.

Fuck. Colm, you have to look after this

COLM: I know, I know, sorry.

BARBARA: I'm not looking after this for you.

COLM: I mean why should you? I prefer it when you do it. It's better when you do it.

She takes a deep breath. Opens the bag, takes out a small bottle of vodka, pours it on a clean rag, dabs at COLM's wound, causing him to wince. She dabs again at the wound, this time more gently.

I can't help thinking about the sheep.

BARBARA: Forget the sheep.

COLM: No, I have. I've forgotten them. I've completely forgotten them, but I can't help thinking about them nearly constantly.

Up there. Eating grass. We can't eat the grass. I keep looking at the grass, this feeling in my stomach, this

emptiness and of course I feel I'd like to eat it but I can't. But the sheep can.

BARBARA: Well, they're sheep.

COLM: Yes.

BARBARA: Forget the sheep.

COLM: I've forgotten them. But how can we eat the grass? I think I've figured out a way we can do it. Do you want to hear? do you want to hear how we can eat the grass?

She doesn't answer.

We get a sheep to eat the grass and then we eat the sheep.

BARBARA: Are you delirious?

COLM: We need food.

BARBARA: It's too exposed.

COLM: Yes, but you see, I've had this idea. Do you want to hear the idea?

She finishes cleaning the wound. Beat. She takes out a needle, dips it in the vodka.

BARBARA: No.

She works on getting the grit out of the cut. He stays silent as long as he can.

COLM: We go up there at night. Unseen.

She says nothing.

We have a fire at night, smoke at night. No-one will see us at night. We go up there at night, we get ourselves a sheep and we eat it.

She has got the grit out.

BARBARA: There.

She puts the needle away, goes back to cleaning,

It's a good idea.

COLM: Is it?

BARBARA: Yes. I tried it.

I went up there at night. Night before last.

COLM: You didn't tell me.

She cleans.

And?

BARBARA: Are you eating sheep? Do you see a fucking sheep?

It's too dark. You can't see a thing. They're up there on the mountainside, you'd break your neck before you get up there.

Forget it. Forget the sheep.

She cleans. He is silent.

COLM: It was a nice idea, though, wasn't it.

BARBARA: Yes. It was.

Beat.

COLM: All that sheep.

Mutton. Lamb. Minted lamb. Lamb cutlets. Lamb chops.

Rack of lamb.

Lamb tikka masala

BARBARA: Do you mind?

COLM: Sorry.

Beat. She pulls out a clean rag to use as a bandage.

What did you do? For a living?

BARBARA: I don't want to talk about before.

COLM: No, no, of course.

Did you have a boyfriend?

BARBARA: I don't want to talk about –

COLM: In my mind I imagine you very good at school.

She puts the bandage around his neck and pulls. He is shocked, for a second choking.

BARBARA: I don't want to talk about my childhood with you. Okay?

He nods. She lets go. He sits there, trying to catch his breath. She lets him and then finishes dressing his wound.

COLM: I can't stop looking at the sky.

BARBARA: Right. When we make a fire tonight you make sure you clean these.

Suddenly it starts to snow. They look up.

What?

They hold their hands out.

COLM: Snow? It's not cold.

She rubs some in her hand.

BARBARA: Ash.

COLM: Ash? Falling out of the sky. Someone must be burning something. It's not from near here. What do you think they're burning?

They stand for a moment. They suddenly run into the shelter, away from the ash. They brush it off them, desperate to get it away from their bodies. They stare at each other. They watch the ash fall.

* * *

Night. They are sleeping, the fire having gone out.

COLM suddenly wakes with a start, sits up, stares around. He is muttering to himself, wild eyed. Seems to be seeing things, frightening things. He scrambles over to BARBARA. Sits there, rocking. Wakes her.

COLM: There's cats, cats, there's cats.

BARBARA: What? What's wrong, what's…?

COLM: Cats, look at these… there's, I mean everywhere, look, there's…

(Suddenly looking up.) Up there, look in the, look, they're in the tree, how did they get…? What are they doing?

Barbara is sitting up now.

BARBARA: Colm?

COLM: Yes?

He looks at her as if for the first time.

Are they here for the food?

Beat. She watches him. He points at nothing.

He's licking his lips. Why's he doing that? Why's he licking his lips?

He looks around, everywhere, the trees, the ground, the bushes.

(The one licking his lips.) Look at him? Look at his eyes. His eyes are so big. He's the leader, he's the one. What does he want?

She puts her hands on him, feels him shaking. Touches his forehead.

BARBARA: Jesus Christ, you're burning up.

COLM: Am I?

BARBARA: Yes. You're shaking.

COLM: That's the cats.

BARBARA: No, it's a fever, sit down.

He goes back to the fire and sits. She tries to restart it.

Jesus Christ, you fucking idiot, I told you to look after this.

COLM: Sorry Barbara

BARBARA: I said. I said look after this, for Christ's sake, you're such a child!

She has started the fire.

How do you feel?

COLM: Freezing.

She puts her blanket around him, then hers.

No, no, that's yours, that's

BARBARA: Shut up.

COLM: They're not real, are they. The cats.

BARBARA: Can you still see them?

COLM: Yes. I can see them. I can see their fur, their eyes, their paws, their tails. I can see their eyes.

She goes in to get something. COLM looks at the cat-leader.

He's smiling. He's smiling at me. He knows something. Oh god.

She goes to his bandage.

BARBARA: Look, I'm gonna take this off, okay?

He nods. She undoes his bandage. He winces. She pauses, then continues, carefully until it is off. She is not at all happy with what she sees. She begins to clean the cut.

All you had to do was look after this. Change it, clean it, look after it, that's all you had to do.

COLM: Thank you.

BARBARA: Shut up.

COLM: Okay. Thank you.

BARBARA: I said shut up.

COLM: Okay.

Thank you.

* * *

Later. BARBARA sits, tending COLM. He is half asleep, half awake, muttering to himself, shivering, delirious. His teeth are chattering. She has taken the bandage off his head, now cleaning the cut again. Leaves it open to get some air. Mops the sweat from within his clothes. Continues. Beat. She stands, looks up at the sky. In the east it is getting lighter. She goes to kick the fire out. Stops. Looks at COLM. Long pause. She leaves it burning and sits with COLM instead.

* * *

Morning. The fire is still going. COLM's head is in BARBARA's lap. She watches over him. He opens his eyes. Looks up at her.

COLM: I did such a terrible thing to you.

Silence.

We should, we should put the fire out.

BARBARA: It's okay, don't worry. Are the cats still there?

COLM: Yes.

BARBARA: You just have to rest. You just have to rest for a while.

COLM: I did such a terrible thing to you, Barbara. I did it for no reason.

BARBARA: Don't talk.

COLM: I had a son once. He was my son. I was terrible to him.

BARBARA: Don't talk, Colm.

COLM: But I was so terrible to you. I want to ask your forgiveness, but I don't want you to forgive me.

BARBARA: Just rest.

COLM: I don't deserve forgiveness. Your forgiveness would break my heart.

BARBARA: Colm – just rest.

COLM: Okay. Yes, of course. Okay, I'm going to just rest, then.

He closes his eyes. Silence. She dabs at his cut. It seems cleaner, less angry. She changes the part of the cloth she is using, trying to find a clean part, but no part that she finds satisfies her. Finds a bit. Examines it. Isn't happy. Very carefully she gets out from under COLM, not wanting to disturb him, gently placing his head on the ground. Goes over to her pack. Roots around.

Barbara? The cats have gone.

BARBARA: Well, that's good then, isn't it.

It takes a while for her to find a cloth that she is happy with. Tears it into a couple of strips. Goes back to COLM, picks up the alcohol, seeing that there is only a little left. Looks down at him.

Colm?

No answer.

Colm?

No answer. She kneels, touches him. Snatches her hand back. Beat. Feels for a pulse on his wrist. None. Feels for a pulse at his neck. None. She puts her head to his chest, listens. Nothing. Stands. Silence.

Oh.

Right.

She is staring at him. Absentmindedly she puts the fire out. Stares at COLM. COLM does not move.

* * *

BARBARA sits, staring at COLM. He now has a blanket over him, head and all. She has the alcohol in her hand. Goes to put it away. Stops. Drinks it off, wincing at the taste. The bottle is empty, she drops it. She gets up, looks at the sky. Looks at COLM. Goes back into the shelter, continues to look at COLM.

* * *

Later. Night.

COLM still, the blanket over his head, BARBARA preparing some food. She opens the can, pulls out two plates, automatically scoops food out onto one, then goes to put food on he other. Stops. Realises there is no point. Her hand hovers there, indecisive. For a long time. She seems to be fighting something. She puts food on the other plate too, then puts the food away. She eats her food. Gone in an instant. Looks at the other plate. Looks at COLM. She wolfs his food down too.

* * *

Morning.

BARBARA stands, looking down at COLM. She looks around. She goes to his head, bends down and grabs him under the arms. She adjusts her weight and begins to drag him away from the camp.

Drags.

Drags.

Drags.

Suddenly COLM sits up with a start, bolt upright, scaring Barbara almost to death, so that she scramble/falls so away and begins to run as fast as she away, having to stop herself. She stands there panting, heart pounding, staring at him. He is looking up at the sky in wonder. Long silence.

COLM: Is this the afterlife?

* * *

BARBARA is working on a snare made from string. It is pegged to the ground. COLM enters. His arms are full of rocks. A moment.

COLM: Shells.

These are shells.

BARBARA: Those rocks?

COLM: Yes.

BARBARA: Those rocks are shells?

COLM: I was up on the hillside, right up the top there, I wanted to get closer to those clouds. Right up on the top.

And It was scree. But not scree, I don't even know if scree's the right word, in fact I don't even know what scree is, but it seems like the right word doesn't it, it seems to fit so yes, scree, so I'm sitting up there on this scree, stones strewn around.

And in my hand is this stone. This lovely, rounded rock, about the size of a fist and suddenly I thought 'flint'.

And I remembered my spear and how useless it was and I thought people used to make flints and they used flints to cut things, people not dissimilar to you and me, in fact people just like you and me, and I looked at this stone in my hand, this rock, and I smashed it down on this boulder as hard as I could.

I cracked it down. And broke it in two.

Pause.

BARBARA: And did it make a flint?

COLM: No. Flint is a type of rock, this wasn't flint. A flint needs to be made of flint. It was useless.

But when I looked at the rock I saw this shell inside.

Beat.

BARBARA: Inside the

COLM: Inside the rock, yes. I saw this fossilised shell inside the rock, the shell of a sea creature. Inside the rock. Look.

He shows her.

See?

BARBARA: Oh, yeah.

COLM: You see?

BARBARA: Yeah, I see.

Wow.

Beat.

COLM: There are hundreds of them. Thousands, hundreds of thousand, probably, lying on the ground, you can just pick them up.

I began to realise that this tip, this piece of rock being pushed up through the hillside had once been the bottom of an ocean.

And I was struck still by time.

I was struck still by time.

And I suddenly saw my infinitesimal place in it and it was… Infinitesimal

And I felt such a peace, such a weightlessness, that I had never known since I was a boy.

Pause.

BARBARA: And… and the rocks?

COLM: They're all shells, Barbara. I realised the hill was strewn with ancient shells and I gathered as many as I could and I brought them here.

BARBARA: Right. Why?

COLM: Why?

BARBARA: Why did you gather them?

Beat.

COLM: They're shells.

BARBARA: Yes. But what do you need them for?

He is staring at her. Looks at the rocks. Looks back at her.

COLM: I don't. I don't need them for anything.

Beat. He drops them. Looks up at her. Smiles, broad and clear.

BARBARA: How do you feel?

COLM: I feel absolutely fine.

She touches his forehead, then his cheek.

BARBARA: It's completely gone.

COLM: What are you making?

Beat.

BARBARA: A snare.

He comes over.

The animal goes in here and –

You have to make sure there's only one way in, but that's easy. Then you peg this end down, they go in here

COLM: Right

BARBARA: and it closes

She demonstrates.

around it's neck. They struggle to get free, but it just makes it worse and… they die.

COLM: And we eat them.

BARBARA: And we eat them. I tested it.

And it works.

COLM: Really? That's fantastic.

BARBARA: I know.

COLM: Oh, Barbara, that's fantastic. So you caught an animal?

BARBARA: No. I've only got string, cloth. It bites its way through. We need wire.

COLM: Do we have wire?

BARBARA: No.

Sorry.

COLM: Oh no, no, I mean... It's not your... I just thought we might have...

He sits, deflated.

We haven't got any food now, have we?

She doesn't answer, sits with him.

I think we need some food. I think we really need some food.

BARBARA: I'm sorry I thought you were dead.

COLM: Maybe I was dead.

BARBARA: You can't be dead for that long.

COLM: I should've looked after my cut.

BARBARA: Yes. You fucking idiot.

He smiles. Her too, almost. A silence between them.

COLM: I had this idea. And I think it might not work, but it might, so I'm going to tell you anyway.

BARBARA: Okay.

COLM: Tonight is the full moon.

BARBARA: Right.

COLM: I mean if these clouds clear. I think these clouds might clear.

There might be enough light. We could get a sheep.

Beat.

What do you think?

BARBARA: I think…

You think these clouds might clear?

COLM: I think they might.

BARBARA: I think… then I think…

I think if there's no clouds…

Then I think…

* * *

They sit, looking up at the sky, waiting. Waiting.

* * *

Morning.

COLM and BARBARA sit eating cooked meat. They are silent, fully focused on what they are doing, not wolfing the food, but not messing around either. This goes on for some time.

BARBARA indicates a can of water, by COLM. He passes it to her, no words needed. She drinks half of it. Offers it to COLM. He shakes his head, then changes his mind, indicating that he would like some. She hands him the can. He drinks half of what remains, then remembers her, offers it back. She considers but then shakes her head. He smiles his thanks to her and drinks the rest off. They both return to their meat.

They eat. Quiet, focused. COLM finishes, all that is left is bone, all meat sucked and winkled from it. He looks at it. Gives it a bit of a gnaw, but that doesn't really work. He places it down on the blanket in front of him for consideration later. She notices that he has finished.

BARBARA: Do you want some more?

COLM: Is there more?

BARBARA: Yeah, there's loads,

COLM: Don't we need it for

BARBARA: There's loads

COLM: later, or

BARBARA: There's loads for later, get some more.

Beat.

COLM: I might have a little more.

He goes back inside the shelter, returns with some warm meat.

Would you like some more?

Shakes her head, not looking up from her eating.

I might have a little more, just this little bit. I don't want to be greedy.

BARBARA: Fuck, eat, get full, fill up.

He looks at the meat in his hand. Puts a bit back. Sits back with her. They eat. Finish. They sit, satisfied. Exchange a look. Suddenly they are laughing. Subsides. They enjoy the silence and the feeling of being full.

COLM: How long do you think it'll last?

BARBARA: Raw? A couple of days?

COLM: We could cook it. It's a lot to cook. How long do you think? Cooked?

BARBARA: Week? Maybe? I mean out here?

COLM: What if we were to take it higher? Isn't it colder the higher you go?

BARBARA: Is there ice?

COLM: No.

BARBARA: Snow?

COLM: Snow, no.

BARBARA: Right. I don't think it'll make a difference then.

Pause.

COLM: You can preserve meat though, can't you?

BARBARA: Oh yeah, you can preserve meat. You can preserve meat with salt.

COLM: Do we have enough salt?

BARBARA: Nowhere near enough.

COLM: We won't be able to get another one until the next full moon.

Beat.

BARBARA: Look, we'll put it into the coldest part of the shelter, we'll cook most of it and it'll last as long as it lasts.

COLM: We can put rocks round it. That'll keep the temperature down.

BARBARA: Good idea.

COLM: Yes. I can gather the rocks.

Long pause.

Can I tell you, I think that's the best sheep I've ever eaten?

BARBARA: You don't think it was a bit tough?

COLM: It was beautiful

He lies back on the grass.

BARBARA: It was.

She starts fiddling with the bones. Pause.

(Almost to herself.) Keep these for soup.

Long silence. She sort of sings under her breath.

COLM: It's probably wrong of me to say this, but I feel happier now than I've ever felt in my entire life.

Suddenly he sits up.

Wire!

BARBARA: What?

COLM: Wire! I got wire! While we were searching, I almost forgot

He pulls out some coiled up wire.

Wire.

They stare at it.

When we split up to search, there was a fence, I think it was an electric but with no electric anymore and I saw this wire and I thought wire. So I took it.

She takes it.

BARBARA: We can trap with this.

COLM: With your snares, you can make beautiful snares with this.

BARBARA: We can trap and eat.

COLM: We can eat animals

BARBARA: Yes. We can eat animals.

Pause.

Thank you.

COLM: You're welcome.

Beat. Suddenly they both jump up and look to the left, both completely silent and focused. Pause. They speak in whispers.

Was that…?

BARBARA: Did you hear that?

COLM: Shhhh.

They listen. Silence. In the distance a voice. A second of indecision.

They leap into action, BARBARA heading to the ropes, lowering the shelter. COLM packs everything into it. The shelter goes back down to the size of the hedges and BARBARA pulls the rope down so it cannot be seen. COLM grabs the mat that he made and pulls it back with him, over the shelter, waiting for her to get in, then they cover the entrance with the mat (plus a few branches).

They are relatively hidden.

A Woman walks on with a prisoner, bound and gagged, a Man carrying a gun following. The prisoner is MARTIN, terrified. They walk slowly, bored and tired. They are almost gone, when the Man stops.

MAN: Can you smell meat?

WOMAN: Can we just do it now?

MAN: What?

WOMAN: Can we please just do it now, please?

Beat. The holds out his hand for the gun. But instead she hands him a length of rope.

New initiative. Save bullets.

He glares at her, but takes the rope. He gets a grip on the rope, puts it round MARTIN's neck, strangles him, putting all his strength into cutting off the air supply. MARTIN bucks, but the Man holds tight. While this happens the Woman steps back. Raises the gun.

MARTIN stops kicking. Man keeps the pressure on for some time then lets go. MARTIN falls, dead, the Man pants. Behind him the Woman the points the gun at his head. Catches his breath. Stops. Stands.

MAN: You know, I really can smell mea –

She shoots him in the head. He collapses. Beat. She frisks his body, takes what she needs. Sniffs the air. Sniffs again. Sniffs the dead Man. Sniffs her own armpit. Shrugs. Leaves the opposite way from which she came.

Silence. After a while the hedge moves. BARBARA and COLM come out. COLM goes immediately to the bodies, looking down, BARBARA looking to make sure that the Woman is gone. COLM suddenly recognises MARTIN. Shock. Goes to say something. Doesn't. Looks up at BARBARA, as she turns to him. They exchange a look. Beat.

They begin to drag the bodies off.

* * *

COLM sits in front of the shelter, which has been returned to full size. In front of him is a big pile of nettles and he is stripping the leaves from them with his bare hands, happy in his work. Also in front of him are the furs of ten or more small animals, along with a sheep's fleece.

He works. BARBARA comes in. She has a clutch of small animals with her, a couple of squirrels, a rodent, a rabbit. He sees her. Smiles. She holds up the animals.

COLM: Another rabbit.

BARBARA: He's a beauty.

COLM: *(Coming over inspecting.)* He's a beauty, look at that…

BARBARA: And I caught a couple of squirrels and I don't know what this is.

COLM: Is it a rat?

BARBARA: It's not a rat, no, but

COLM: A vole, maybe? Maybe it's a…

BARBARA: There's meat on it.

COLM: There is, there is. Lets call it a vole.

BARBARA: A vole then.

COLM: Look at that rabbit!

BARBARA: She's a beauty, isn't she?

COLM: She is a beauty!

BARBARA: Is there water?

COLM: *(Going to get up.)* Let me get you some.

BARBARA: No, no, don't worry. I'm up.

> *She goes into the shelter. COLM continues to inspect the catch. She comes back drinking a can of water. Looks at him.*

Nettles?

COLM: Yes.

BARBARA: You're not wearing gloves.

> *She goes over. Touches a nettle, immediately snatches her hand back, stung. He picks it up and strips the leaves off, demonstrating to her that he is not stung at all. Pause.*

COLM: I can't help seeing it as a positive sign.

I know I've probably just built up an immunity, but I can't help seeing it as a welcoming, or

Beat.

I know. I know, it's stupid and I don't really believe that, but as I've sat here, stripping these nettles I can't help feeling that I've become, a little bit, of late, animistic.

BARBARA: Animistic is it?

COLM: I've imbued everything around me with a kind of spirit, I know it's just my mind, my fancy, but it feels so

real, that I find it hard not to believe in it. In fact I do believe it, knowing it can't possibly be true.

And I feel that these nettles are in fact absolving me. They are delivering absolution to me. But, try as I might, I cannot find one single, solitary reason on this earth why I should be absolved.

Pause. He carries on stripping the nettles. She comes over.

BARBARA: You've got the skins out.

COLM: I've been looking at ways to bind them.

BARBARA: Did it work?

COLM: They need to dry a little more, but I think we can sew and tie them together.

It's getting colder. Have you noticed?

She doesn't answer. He is cautious.

I've… been thinking about winter.

I thought maybe, if we were, you know, if by some chance, if by some chance we were still together then warmth would be…

Pause.

Sorry. I'm sorry, forget what I said, forget, that's not… I'm sorry.

He can't look at her. She watches.

BARBARA: Another two months before it gets really cold. At least another two fleeces. Factor that in.

He is stuck by what she has said. He turns to her, but she is walking back to the shelter returning the water can. He recovers.

COLM: I think… I think autumn will be good.

BARBARA: Yeah?

COLM: For gathering, yes. There's oak, so acorns, you know. I think you can eat acorns. In fact I remember reading about a society that lived almost exclusively on acorns, though that's not a good example as they died out, largely because they lived exclusively on acorns, but still I think they would be good to eat as a supplement. And I believe, I believe that these people made flour from the acorns.

BARBARA: Acorn flour?

COLM: Acorn flour, which is a great way to preserve and make it go further.

BARBARA: We could make acorn bread.

COLM: Yes, yes, some form of flat bread, I imagine.

BARBARA: I think there gonna be a lot of blackberries down there.

COLM: Oh, there are going to be tons of blackberries and fruits and nuts in general, I imagine. The trick will be to store.

I've always been frightened of winter. But I don't feel frightened of this one. This is the most frightening winter I've ever faced.

She sits. Pause.

BARBARA: We went to Italy one winter. When I was about eight. Because my dad hated the cold, hated it, every winter he'd moan. So this one time he said 'no way' and we went to Italy, Milan, I think it was. The whole lot of us. For two whole months. Said he was going to war on winter, said this year we were going to win.

Beat.

It snowed and snowed and snowed. I mean it really fucking snowed, my dad was fuming, he was, I mean this was one of those places that never snowed, I mean maybe it wasn't Milan then because I think it snows there, but wherever it was it just kept snowing, and all the locals are out in the streets in wonder, because they've never seen,

they're celebrating, because it never snowed and dad was… fuming, it was…

We just laughed. To see him sulking, you had to laugh.

We made a snow man. Dad called him 'Giovanni, il uomo neve'.

COLM: I remember he hated the cold.

Pause.

If I could do only one thing different, Barbara…

BARBARA: Well.

Let's leave that.

COLM: Yes. Yes, of course.

Silence. She lies back, enjoying the sun. The silence persists, but comfortable, COLM stripping nettles.

BARBARA: Sun. Sunshine.

He looks up.

COLM: Only ten per cent of all of the energy that a plant absorbs in its lifetime goes into the fabric of the plant. The fibres, the leaves the cells and sap. Only ten per cent. And when an animal eats the plant it's really eating that ten percent, it's eating ten percent of the sunshine the plant absorbed in its lifetime.

And only ten percent of all the plants that the animal eats, only ten percent of *that* energy goes into *its* body. Ten per cent. Isn't that amazing? And on and on, all the way up the food chain, whether it's a rabbit or vole, or caterpillar or bacteria or you and me, ten per cent, and no-one really knows why, but we only get to keep ten per cent. The rest of it…

Beat.

And we put so much store in that ten percent. The bits we keep. But what about the other ninety? We hardly notice

the ninety. Day to day it dissipates in the most beautiful ways, incredible ways, but so concerned are we with the ten per cent, we just… hardly notice.

Life hardly noticed.

Beat. She lies back on the grass.

I'm confused by the amount of sense this makes.

I'm in love with the amount of sense this makes.

BARBARA: Are you going to talk all afternoon?

He thinks.

COLM: I might.

Is that alright?

Beat.

BARBARA: Yeah. Knock yourself out.

Beat.

COLM: The universe has been here for fifteen billion years. We've waited fifteen billion years for this moment. For this moment.

And now it's here.

He picks up a nettle to strip, but immediately drops it, stung. He looks at it, shocked, but BARBARA hasn't noticed. Beat. There is a faint crack in the distance. BARBARA sits up.

BARBARA: What was that?

Beat.

Was that…

a shot?

There is another crack. Beat. BARBARA slowly and gently slumps forward, until she is lying prone on the ground. She doesn't move.

Silence. COLM stares at her. He is frozen. He reaches out his hand. Hesitates. Touches her back. His hand comes back covered with blood. He stares at her.

COLM: What?

Beat. Soldiers enter, guns raised pointed at COLM. He stares at them. One comes forward. COLM shows him his hand.

This is blood. Is… is this blood?

The soldier raises his gun.

CASTILE: *(Off.)* STOP!

CASTILE runs on.

Stop! Stop, stop, it's him, it's him, it's him, this is –

Put your guns down, this is him, it's… Guns down, now!

Beat. They wait for the soldier closest to COLM. He seems to be considering shooting, but lowers his gun, nodding to the others. They do likewise. CASTILE turns to COLM. He is staring at BARBARA.

COLM: Oh dear. Oh no. Oh no, no, no, not that, that's…

That is… That is…

No, no, no, no, no, not that, that's…

CASTILE: Colm? Colm it's me, Castile.

COLM: What is this? This can't be right, this can't be

I mean this can't be right, or… I thought it was alright. I thought it was, I thought I'd, everything had, you know, I thought, I thought I'd, I thought I'd…

I thought everything was fine. This can't be right. Is this right? this can't be right, not now, please. Please. Come now, please.

CASTILE: Colm? Colm, sorry about the girl, it was… no-one meant –

COLM: Who are you?

What are you doing here, who are you, who invited you? You're not invited, none of you, what do you think you're doing? You're breaking it. Look at what you're doing!

Go! Go on go, all of you, get out of here, go!

CASTILE: Colm, it's me, I've found you, we've come to find you.

COLM: No, no, that's not right, this doesn't make any sense at all. Please, enough now, this is silly, go, please, you are not supposed to be here, you are not supposed to…

Tries to push them out. They don't move. CASTILE stops him.

CASTILE: I've been looking for you, we've been looking for you. We've come to take you back, your son, Colm, your son has changed everything, everything is –

JIMMY enters. He wears fatigues. Looks very different. All the soldiers stand back. It is obvious he is in charge.

You're son is here. He's in control. Richard is dead, Beth is dead, Gavin is dead, there are no more tyrants, this –

JIMMY: Father?

COLM stares at him as if he were a ghost.

COLM: My…? My son?

JIMMY kneels. COLM slowly moves over to him.

My son?

JIMMY: I've been searching for you, I've been looking for you.

I want you to come home. I just want you to come home, everything's different now, I've changed so much, everything that passed between us, that's over, I want that over, I want you to come home. You were right. I'm not like you. But just come home.

COLM: Home?

Can you bring her back?

JIMMY: What?

JIMMY stares at him. Looks at BARBARA. Stands.

No. No I can't.

For a second COLM looks like his heart might break, but suddenly realises something. Sags with relief.

COLM: She's sleeping.

No, no, yes. That's it.

Yes, that's it.

He is suddenly filled with relief.

Oh god, yes, that's it, she's sleeping.

The reprieve almost overwhelms him.

Oh good god, I thought… I thought the most terrible –

I had this dream. This awful terrible dream, a dream raped, I dreamt that I would regain myself, that I would live, that I would breath, that I would in fact come to an understanding of beauty so that this moment could be snatched away from me while I watched.

JIMMY: Father, forgive me, please, I want your forgiveness, I want –

COLM: Shhhhh! She's sleeping. Who are you? Do I know you?

JIMMY: It's me!

COLM: Me?

He is suddenly confused.

Are you… me? I thought I was me.

CASTILE: Please, Colm, listen –

COLM: Can you tell me something?

I want you to tell me something, can you tell me something?

I've just had this horrible dream and I have this feeling that there is something terrible, just down here, there, something terrible and I know there isn't and it's stupid and yes, yes, but I need you to look. I need you to look down there and tell me what you see.

Beat.

CASTILE: A body.

COLM stares at him. He suddenly notices the blood his hand. His eyes widen. He recoiled, as if trying to get away from his own hand. He wipes it frantically on the ground as if getting rid of the substance will get rid of the nightmare.

They watch, silent. He suddenly stops. Looks up at BARBARA. Sees her. Sees that she is dead, like discovery.

COLM: Please. Please, not that. Not that, no, no, no, not that, that's, please.

CASTILE steps forwards.

DON'T TOUCH ME!

Who are you? What are you doing here? Why are you breathing? Why are you breathing, when she isn't?

JIMMY: Who is she?

COLM: She is my daughter. My daughter is dead.

CASTILE: No, no, Colm, you –

COLM: Yes, she is! I know when someone is alive and when they are dead and she is dead.

They watch. He looks up at JIMMY.

Take this moment back. Please.

JIMMY: I can't.

COLM: Please. It's easy, just take it back? What? Not easy then? Oh. Sorry. So sorry, but please, please do this thing, please.

JIMMY: Father it's me! It's your son!

But COLM can only see BARBARA's corpse.

SOLDIER: He's broken.

CASTILE: Colm?

SOLDIER: What use is he to us?

CASTILE: He is a great man.

SOLDIER: Not any more.

ANOTHER SOLDIER: We should put him out of his misery.

COLM: Please.

SOLDIER: What are we going to do?

JIMMY: Take him with us. He's my father.

COLM: Please.

JIMMY: I love him.

COLM: Please.

He is staring at BARBARA.

Not this. Not this.

Please, darling.

Not this.

END